The primacy of touch

THE DRAWINGS OF PETER MILTON

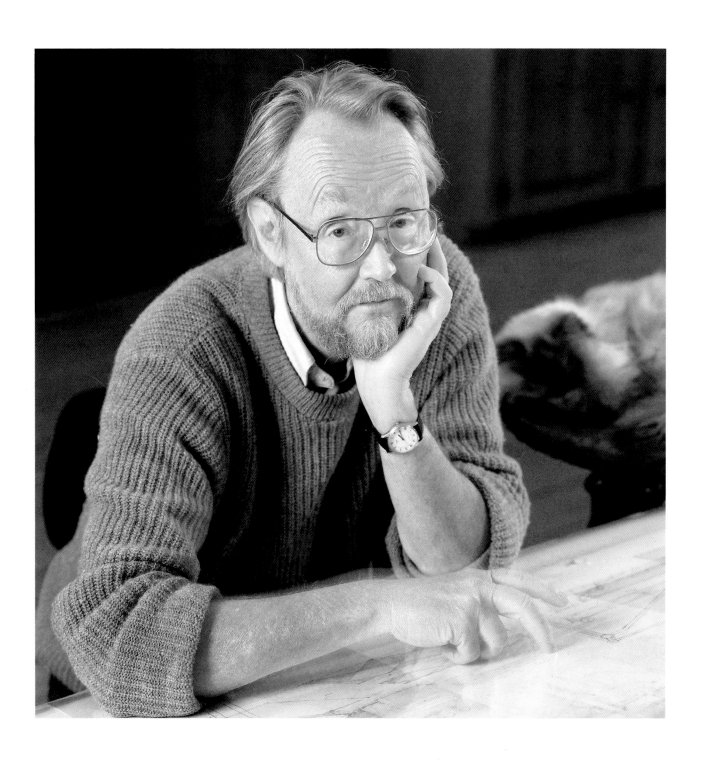

The primacy of touch

THE DRAWINGS OF PETER MILTON

A CATALOGUE RAISONNÉ

Text by Peter Milton

Introduction by Rosellen Brown

HUDSON HILLS PRESS
New York

Photograph credits

Frank Cordelle: 123–25

D. James Dee: 25, 34

Hilary Felstein: 11

Mark Gulezian/QuickSilver: 38

Britain Hill: frontispiece, 122

National Museum of American Art, Washington, D.C.: 80, 81

Rhode Island School of Design, Providence: 35

Dana Salvo: 20, 96–119

Lee Stalsworth: 30

FIRST EDITION

© 1993 by Peter Milton

Introduction © 1993 by Rosellen Brown

All rights reserved under International and Pan-American Copyright Conventions.

Published in the United States by Hudson Hills Press, Inc., Suite 1308, 230 Fifth Avenue, New York, NY 10001-7704.

Distributed in the United States, its territories and possessions, Canada, Mexico, and Central and South America by National Book Network, Inc.

Distributed in the United Kingdom and Eire by Art Books International Ltd.

Distributed in Japan by Yohan (Western Publications Distribution Agency).

Editor and Publisher: Paul Anbinder

Copy Editor: Virginia Wageman

Proofreader: Fronia W. Simpson

Design and composition: Betty Binns

Manufactured in Japan by Toppan Printing Company

Library of Congress Cataloguing-in-Publication Data

Milton, Peter, 1930–
The primacy of touch : the drawings of Peter Milton : a catalogue raisonné / text by Peter Milton : introduction by Rosellen Brown.—1st ed.
p. cm.
Includes bibliographical references (p.) and index.
ISBN 1-55595-075-2
1. Milton, Peter, 1930– —Catalogues raisonnés. I. Title.
NC139.M55A4 1993
741.973—dc20 93-17551
 CIP

Contents

List of illustrations 7

The magic theater of Peter Milton
BY ROSELLEN BROWN 9

THE PRIMACY OF TOUCH *by Peter Milton*
 I About my drawings 15
 II Some notes on *The Train from Munich* 86
III *The Aspern Papers* 92
IV Inward and onward 120

Chronology 126

Solo exhibitions 128

Selected public collections 130

Selected publications 131

List of illustrations

Peter Milton frontispiece

The Milton family 11

Interior with Small Head, 1967 20

The Jolly Corner, 1969–71

Sequence I, Drawing #1 21

Sequence I, Drawing #2 22

Sequence I, Drawing #2, detail 23

Sequence I, Drawing #3 24

Sequence II, Drawing #1 25

Sequence II, Drawing #2 26

Sequence III, Drawing #1 27

Sequence III, Drawing #2 28

Sequence III, Drawing #2, detail 29

Passage: Icarus at Marienbad, 1971 30

Small study for *Sky Blue Life*, 1976 31

Small study for *Passage III*, 1972 31

Small study for *Collecting with Rudi*, 1974 32

Small study for *Collecting with Rudi*, 1974 32

Small study for *Collecting with Rudi*, 1974 33

Small study for *The First Gate*, 1974 33

The Theft, 1974 34

Daylilies, 1974 35

Study for *Les Belles et la Bête I*, 1976 36

Study for *Les Belles et la Bête I*, detail 37

Study for *Les Belles et la Bête II*, 1977 38

Les Belles et la Bête I: The Rehearsal, 1977 39

Les Belles et la Bête II, 1977 40

Study #1 for *Les Belles et la Bête II*, detail 41

Study #2 for *Les Belles et la Bête II*, 1978 42

Study #2 for *Les Belles et la Bête II*, detail 43

Les Belles et la Bête II: Before the Hunt, 1978 44

Les Belles et la Bête II: Before the Hunt, details 45

Study #1 for *Les Belles et la Bête III*, 1979 46

Study #2 for *Les Belles et la Bête III*, 1979 47

Study #3 for *Les Belles et la Bête III*, 1979 48

Study #3 for *Les Belles et la Bête III*, detail 49

Study for *Country Pieces I: The Couple*, 1979 50

Study for *Country Pieces II: In the Park*, 1979 51

Les Belles et la Bête III, 1980 52–53

Splash, 1980 54

Butterfly, 1980 54

Dancing Lesson, 1980 55

Notes, 1980 56

Europa, 1980 56

Pas de Deux, 1980	57	
Stolen Moments, 1980	58	
Stolen Moments, detail	59	
Io and Jupiter, 1980	60	
Inner City, 1981	61	
Splash 1981, 1981	62	
Splash 1981, detail	63	
Friends, 1981	64	
Friends, detail	65	
Kick in the Pants, 1980	66	
New Act, 1981	67	
After Degas, 1982	68	
After Degas, detail	69	
New Act (second version), 1982	70	
New Act (first version), detail	71	
Dancing Lesson (second version), 1982	72	
Dancing Lesson (second version), detail	73	
Io and Jupiter (second version), 1982	74	
Io and Jupiter (second version), detail	75	
Klimtomania, 1982	76	
Study for *Time with Celia*, 1985	77	
Interiors I: Family Reunion, 1984	78	
Interiors I: Family Reunion, detail	79	
Interiors II: Stolen Moments, 1986	80	

Interiors III: Time with Celia, 1986	81	
Interiors IV: Hotel Paradise Café, 1987	82–83	
Interiors V: Water Music, 1988	84	
Interiors VI: Soundings, 1989	85	
Interiors VII: The Train from Munich, 1991, etching and engraving	87	
Interiors VII: The Train from Munich, 1991	89	
Interiors VII: The Train from Munich, details	90–91	

Drawings for *The Aspern Papers*, 1990–92

I PROLOGUE

Jeffrey and Juliana #1	96
Jeffrey and Juliana #2	97
Jeffrey and Juliana #1, detail	98
Jeffrey and Juliana #2, detail	98

II RECENT SIGHTINGS

Henry in Venice #1	99
Henry in Venice #1, detail	100
Henry in Venice #2, detail	100
Henry in Venice #2	101
Henry in Venice #3	102
Henry in Venice #3, details	103
Henry in Venice #4	104

Henry in Venice #5	105
Henry in Venice #5, detail	106
Henry in Venice #7, detail	107
Henry in Venice #5, detail	107
Henry in Venice #7	108
Henry in Venice #6	109
Henry in Venice #8	110
Henry in Venice #8, details	111

III CAT AND MOUSE

Ca' Cappello #1	112
Ca' Cappello #2	113
Ca' Cappello #3	114
Ca' Cappello #4	115
Ca' Cappello #4, detail	116
Ca' Cappello #5, detail	116
Ca' Cappello #5	117
Ca' Cappello #6	118
Ca' Cappello #7	118
Ca' Cappello #8	119
Garden with Henry, 1992	122
Mary's Turn, 1993	123
Mary's Turn, details	124–25

The magic theater of Peter Milton

ROSELLEN BROWN

Many years ago I lived with a pair of art students who were assembling their earliest professional ideals. The air was full of references to what they loved and what they deplored: Michelangelo's stippled light effects, Cézanne's compositional genius, Gorky's fragmented energy, the ascetic richness of Albers's interaction-of-color canvases, so austere that they were moving. I was myself a graduate student in literature, deep in the thickets of my first Henry James (I had been a poet in college, accustomed to a more rigorous verbal economy), but I was trying to learn a visual taxonomy as well.

It was then that I heard from these vociferous friends the most shameful epithet they could use against an artist: *literary*. *Decorative* ran a close second; sometimes the order of contempt was reversed. But, one way or another, it seemed—this was the early sixties—the painters and printmakers who most offended were those who surrendered purity of means and ends, available through the deployment of shape and color, texture and scale, to a sullying interest in the merely referential. These friends had contempt for ideas and images that might suggest a possible life elsewhere, psychologically problematic, independent of paint or ink, burin or lithographic stone—a life spent dangerously implicated with *words*.

What I should have listened for in those passionate denunciations, I realized only many years later, was all that was implied in that "merely." By *literary*, they didn't necessarily mean works provoked by a particular text. Rather, they likened such work to a certain pandering kind of music that hinted, however distantly, at story, and to didactic prose, political poetry, all of them "about" something when "about" was nothing less than slander. But what about the *Leonora Overture*, what about Yeats's impassioned poems in service to the Irish cause, what about *Moby Dick* or even *King Lear*, in which we may surely divine nightmare visions, social outrage, even oblique lessons in morality? Content didn't really have to be abstract to be complex, did it, I demanded. What it needed was—merely?—to make its "literary" referents only one more element in a multilayered whole, to utilize the full armament

of its medium's possibilities. What it needed was not *to mean*, but (if Archibald MacLeish hadn't written it, someone else surely would have) *to be*.

What Peter Milton constructs—not *merely*, that is, but with a passionate dedication to visual values—are novels, narrative constructions in which character, mood, and setting interact with extraordinary dramatic complexity in time. They are, in that sense, literary with a vengeance. Stories are told and implied. Histories are suggested, personalities juxtaposed, psychologies enacted. With astonishing ingenuity and fluidity he accommodates in a single work all his copious passions: biography, literature, history, art history, theater, music, ballet, architecture, film, photography.

But, though his mysterious scenarios have the heft of novels, what Milton also creates, paradoxically, through the simultaneity of his effects, functions across time the way poems do. A good lyric poem makes many things happen at once: it can allow a grown man, say, to see his child and his father (not to mention himself) in a single instant, or envision for the lords and ladies of Byzantium, in the flash of a line, all that is "past, or passing, or to come." And huge, cannibalizing poems

like "The Wasteland," or Pound's *Cantos*, are collages that borrow wantonly from many sources at once, layering in nothing less than a pantheon of the illustrious dead—artists, historical figures, masters of thought and action whose encounters across the centuries seem to be engineered with equal playfulness and earnestness: no other way could Eliot's Baudelaire, Shakespeare, Madame Sosostris, Bill, Lou, May, and Mr. Eugenides, the Smyrna merchant—or Peter Milton's Duchamp and Wallenberg (*The Train from Munich*)—hope to meet, except, perhaps, in heaven.

(Must we, incidentally, be able to identify the "real" figures of artists, musicians, political heroes, who find their homes in these drawings? Eliot might have answered the same way about his work—he attached end-notes for the curious, those scrupulous enough to need an attribution for every reference—but the poem either works or it does not, on its own. If its allusions and quotations have not been digested and transformed into the artist's own creatures, made of his own familiar materials, he has failed and the result is an uncommunicative obscurity. Milton's drawings may be more dense and satisfying to those who spot his private allusions, jokes, and uninhibited borrowings from photography, but the work is so profoundly realized in itself

that it proves in yet another way that to be referential—literary, perhaps—need not be a burden.)

Yet the most remarkable accomplishment of these rich novel/poems is that they are before all else faithful to the need to move and satisfy us visually. There is no separating Milton's drawings or print studies into separate strands of the literary, the historical, the compositional. Light and darkness, for example, are not casual accoutrements of a larger intention. Spaces may contain architectural fabrications that feed the "plot," but they must at the same time fulfill the needs of the eye. Anyone who ever had the privilege of watching Peter Milton stalk around his studio worrying a background too empty of complication—or, rather, implication—or a leg slightly misaligned so that it fails to lead the eye the way he hopes it will, would understand how his narrative and visual challenges are one, and demand inseparable solutions.

Which is another way to say that this is not illustration. The impetus of illustration is external; its primary stimulus is another work in another medium, the word, the story. The music of Schubert's lieder exists to support a text; a set design comes into being to facilitate the live actors' walk around and in front of it. Milton's scenar-

ios, conversely, are entirely his own, and he sees himself answerable simultaneously to the demands of "literary intention" and to space, light, shadow, line, texture.

Look at the way the white birds in *The Train from Munich* dissolve the darkness and soften the geometry of the railway station; see how the hand extends over—gently shatters—the bottom frame of *Daylilies*; how the formal architectural vistas in *Passage: Icarus at Marienbad*, and *Hotel Paradise Café* divide the page and not only fill it with solid shapes that bespeak lives lived behind firm, even historic, facades but create mass and an intriguing interplay of verticals and diagonals. Those floating billiard balls in *Mary's Turn*—they are magical, like soap bubbles, but they also rivet the eye, holding their own against our surprise at seeing embodied many of the women and children of Cassatt's own paintings. Consider how the intricately tilted poles divide the space beside the seated John Singer Sargent in #8 of *The Aspern Papers*—they are like the musical play of syllables in a poem, not merely narrative devices but satisfying, sensually delicious details that fulfill their own intrinsic formal design. Their function is, as the novelist Elizabeth Bowen once said about good fiction, "uncompromised by purpose"—by which she meant that,

before any programmatic scheme they might advance, they are self-delighting, stimulating. Complete.

If Peter Milton's work dazzles us by its visual inventiveness, its narrative enchantments are endlessly provocative and original.

I have on my wall an old photograph of the Milton family (each of whom has had a poignant part to play in one or more of his prints). Peter is seated on a slatted bench, his wife, Edith, stands beside him in profile, and Naomi and Jeremy, still teenagers, stand decorously behind. But this is not so much an ordinary family portrait as a unique enactment of a fantasy: they are all dressed in Victorian costume. Peter, in fusty black, is wearing a top hat, leaning slightly forward on a walking stick; beside him on the bench is a black Gladstone bag, very serious, heavy looking. Edith wears a long striped dress and the obligatory garden-party hat, and the children are formal, elegant, Jeremy uncharacteristically subdued in a tie, beneath a bowler. This is theater, but a viewer who has encountered the stuff of the pater familias's dreams in his work (not to mention the Victorian-style New Hampshire house he lives in) will recognize the weighty presence of the late-

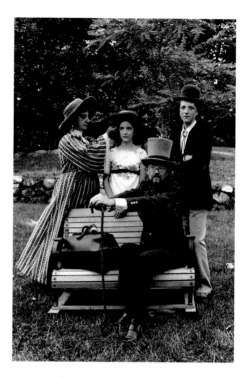

nineteenth-century psyche in his imaginary dramas. Dr. Freud is the angel under whose wing this man works.

Wherever one chooses to look in the drawings collected here, there is the juxtaposition of chaste and provocative images. Somewhere in the landscape a naked woman might materialize, wantonly or shyly. In one of the studies for *Collecting with Rudi*, we see a family, or at least a familial-looking arrangement of good-looking young figures, including a child, sitting for what appears to be a formal portrait before an urban cluster of houses. In

another, Rudi leans forward with an encouraging look, but, like a Pinter character eager to provoke and unsettle, he holds a painting of a nude, a modernized Renoir, her hat halfway out of the frame so as to cast doubt on her status as illusion. And in a third, very real and very inexplicable, sits, unflinching, another naked woman. Half amused and half disturbed, we are left wondering just what kind of passion for collecting this Rudi so shamelessly indulges.

Like this coolly bizarre family gathering, a great many Milton figures look straight out at us; such a frontal view, often a conscious pose, seems to establish contact with the viewer, to promise full disclosure, but of course, given the mysterious relationship of person to place to situation, his figures are, most of the time, in fact extremely reticent. Where there are groups of people they are frequently separated into discrete knots of activity, ignoring each other the way the subjects in old photographs gaze in opposite directions; or they exist in obviously separate planes, possibly separate times. The effect can be very disquieting.

Consider the small study for *The First Gate,* its title from Eliot's "Burnt Norton" ("Through the first gate, / Into our first world. . . . Time past and time future / What might have been and what has been /

Point to one end, which is always present"). Facing us, two little girls are whispering one of the secrets that abound in these scenes—the unsayable, the accusatory, the excluding. Knots of children seem to huddle and gossip in Milton's world, the way we tend to remember from our childhoods when we were, or at least fancied ourselves, outsiders. The mists of repression are pierced by what seem to be remembered fragments of architecture of dazzling clarity, large public spaces in which private dramas are enacted, spiced by dreams of a free sexuality, a mythic beauty. Side by side the children solemnly stare out at us, palpably caught in a youth we suspect is long since gone in that disturbing Miltonic overlap of past and present.

Always the question lingers over these scenes: are we looking at now or then (or now *and* then)? At reality or memory, at actuality or dream, at hope or at dread? Animals walk through the landscapes, dogs at large or, constrained, pulling at leashes; cats lord it or lounge, inviting touch; birds fly, sometimes—that most terrifying of spectacles, heavy with augury—trapped in rooms, wildly careening inside enclosed spaces.

The suites *Les Belles et la Bête* and *Interiors* are a great deal more theatrical, and here another kind of figure asserts itself that

would have delighted Dr. Freud at least as much as the serious children seen in the act of amassing their reminiscences, a presence that functions almost like that of a psychoanalyst keeping a keen (and probably critical) eye on the proceedings. Or might this not be the seducer himself, front and center, the overseeing (always male, always forbidding) authority figure, whether guiding impresario (*Les Belles et la Bête I, II, III*), the two men at the ballroom door (*Hotel Paradise Café, Interiors I: Family Reunion*), or beast with animal head (*Les Belles et la Bête I: The Rehearsal; II: Before the Hunt; III: untitled; Pas de Deux; Stolen Moments*)? Sometimes he manifests himself as guardian at the gate, and then again as serene master cat, book in lap, cigarette in hand, at whose feet lie entangled the most provocative litter of feline girls one dare imagine. Masks, costumes, mirrors; photographs implying images no longer current—again and again we see the disturbing but lovely, stagy but sincere drama of a mind polarized by the sanctioned and the forbidden, the controlled and the controlling.

In print after print, a wistful figure gazes out at us or away from the center of our focus, a watcher taking in the scene. Often Milton seems to build in a consciousness outside the action—the women in *Interiors II* and *III: Stolen Moments, Time with*

Celia, and *Hotel Paradise Café;* the hazy man, described by the artist as the elegant Ravel, gazing in from the right in *Les Belles et la Bête II: Before the Hunt;* and the figure Milton identifies as his wife, Edith, as a girl in *The Train from Munich,* who is living out, simultaneously imagining and remembering, the horrific history of Europe and the Holocaust. In *Mary's Turn,* the brooding man gazing out the door, intended to be the playwright Ludovic Halévy, seems to have removed himself from the action by turning away from it. If this gives the appearance of a morose judgment, that may be because Halévy was a Jew betrayed by his friend Degas's anti-Semitism. No wonder these drawings so often suggest the novelistic: it is as if each contains a witnessing imagination, a slightly dispassionate viewer who resists full participation—that is to say, a narrator. Could it be that the judging, feeling, isolated dreamer is a surrogate for the artist, captured for us to see, along with the dream itself?

Which leads, inevitably, to the remarkable paired suite of Henry James variations, *The Jolly Corner* and *The Aspern Papers.* What an extraordinary coming together of "manifest content," of homage to another artist, of wistful imagery! It is as if James had merely anticipated Milton's preoccupations by a few years, his characters

already dressed just as Milton has always fantasized his own "protagonists," and his choice of venue—especially in *The Aspern Papers*—right out of Milton's sketchbook: Venice, beautifully decaying, replete with hidden, neglected gardens of fecundity, shimmering water, open plazas framed by gorgeous facades, and abandoned interior spaces in which figures can move in isolation, detachment, the kind of terminal loneliness to which both James's and Milton's men and women seem doomed.

Henry James, of course, was the perennial master of reticence and balked desire. His "Aspern Papers," more than almost anything he wrote, seems to call up the peculiar simultaneity of time planes that Milton so loves. The novella presents us with a set of old letters, the lingering evidence of passion long past, and two generations of women, one whose youth has unquestionably withered, the other, fragile, just on the brink, when it may or may not be too late to hope for love, or something like it. In contrast with the glamorous idol, Jeffrey Aspern, in a symmetry not unlike that of Milton's pure and profane women, we see the not-quite-vulnerable narrator, guarded, lonely, congenial but ultimately the trademark James character armored against sexual appeals. The entire drama is played out in a Venice that, like the male and female bodies he

imagines, young and old, seductive and plain, has aged and grown somewhat untended but has not quite lost its extravagant beauty.

No longer is the imagining presence a woman: this time (as in *The Jolly Corner* but far more poignantly because this James is truly in and of the scene—just as implicated as his own characters, not simply the man who creates them) we have *Recent Sightings: Henry in Venice.* In #1, James appears at five different times in his own life. He looks right at us in #4, at the foot of the Rialto bridge, beside a fine, lusty bit of statuary, not coy but rather fleshly and Mediterranean in its abandon. In the drawings with John Singer Sargent we see an artist at work and play, one who dares represent the vigor and impudence of the male gaze, painting in his boat (#5), sitting in a courtyard (#8) catching on his canvas what we can only glimpse, two flirtatiously hidden figures; a shoe barely pokes out from cover. What we can't see, the unshy artist presumably dares to. In fact his work demands it.

We are given combinations and recombinations of figures, a drama of hide-and-seek in empty galleries, and in the last drawings, youth, age, and memory, aided by photograph and painting—all far more suggestive of tender recollection than of present consummation. And crucial to the

whole is the tender, lovely, young (or not so young?) woman we glimpse in the window on the far side of the canal (#7), the same woman, we might assume, who looks down upon the *Garden with Henry*. In that exquisite drawing, James is turned one way, she the other, melancholy, modest. And in a bower we (and they) confront wildly impassioned stone lovers in naked athletic embrace. If there could be a single image to exemplify Henry James's own life—he the sufferer of that "covert injury" that was said to inhibit his straightforward relation to his sexuality—*Garden with Henry* is the one I'd choose: here, with eyes downcast, are innocence, secrecy, longing, lust, and the averted face; here also are intelligence, introspection, judgment, those of the imagined and of the imaginer. It is an emblem, no escaping it, of Peter Milton's work early and late.

If Peter Milton's prints are exhilaratingly rich in their rewards, his drawings are (for me, at least) even more resonant. Whether it is the greater subtlety of what he calls "the touch of the hand," or simply the more tentative stamp of a lighter line and mass, I find these delicate but infinitely complex and profound dramas of the psyche uniquely moving. They map the terri-

tory we writers live in, amidst the rubble of the excavated layers of memory a longing to keep the unkeepable past, to tell stories of a present fatally influenced by that past. But this artist does his work with an immediacy unavailable to those of us doomed to the limitations and slow accretion of words, just as a composer can call forth emotion deep enough to capsize us through the abstractions of song.

But an inch or two of Peter Milton's peculiar and original sugar and ink on Mylar or drafting film, of his pencil dotting emptiness into substance, can seize me by the back of the neck, as Emily Dickinson promised a good poem ought to do, and the experience is inexhaustible. Like memory, these drawings and studies for prints change with every confrontation. They rearrange real history for us, shake up what might have been and resettle it as if probability were negotiable; they hang balls in the air, show us solidity on one side of the looking glass, an airy absence on the other. You can enter them and keep on going.

Peter Milton's early landscapes might be seen as the creation of the world—still unpeopled, relatively uncomplex and not particularly demanding of the viewer's imaginative participation. These are suc-

ceeded by his preoccupation with childhood and the archeological layering of early memory, followed by the middle period's erotic fantasies, the inevitable drama of sexuality and repression, overseen quite theatrically by a stubbornly dominating figure. And finally, in an evolution that Milton himself speaks of as a ripening sense of "inevitability," the artist seems to have accomplished a highly self-critical culling of everything willful or arbitrary, "no fancies running away with me," culminating in the much less playful latest work, which engages world events and social tragedies, innocence and experience, within the same frame.

I don't think of this body of work as literary, my old friends, but as something that synthesizes dozens of significant sources without much regard for trends and fashions. I think of these drawings as magic theater, wind blowing without sadness across the grass of memory, think of them as our hands closing around everything and everyone that leaves us, all beautifully conjured on the eternity of an endless stage. The players take their bows miraculously, side by side the real and the imagined, the dead and the living, looking straight at us, all at the same time.

I About my drawings

I do love to draw. I feel that I am being granted membership in the Brotherhood of Merlin, conjuring forth some apparition. As a drawing develops, I sense a vague presence coming more and more into focus, something in a white fog emerging and becoming increasingly palpable.

I have often wondered how much my delight in this sensation stems from the fact that I have always been nearsighted. I suspect there was a long enough period before the condition was caught in my childhood that my putting on my first pair of glasses at age eight must have been a revelation. Perhaps I have been trying to recapture that epiphany of restored vision ever since. As a child I had been losing Paradise, and suddenly, in one flash, it was regained.

In fact, I must confess that I belong to the school of thought which holds that artistic character is formed as much by one's insufficiencies as by one's proficiencies. It was, for instance, my myopia that led to my fascination with clarity of focus and detail. My red/green colorblindness—another visual handicap—resulted in my choice of textural contrast and its elaboration as the sensuous equivalent for color, and moved me to etching as the richest medium for working in black and white.

I suppose I must add a third affliction here—my low threshold for confusion of any sort. I change from clarity to chaos with unnerving ease. The way I work through this can only be called sheer stubbornness—an application of trial-and-error until a solution reveals itself. The unique advantage of this approach is that—like the apes with typewriters arriving finally at Shakespeare—some resolution inevitably presents itself and, unlike those arrived at via formula, can be quite surprising.

Even in my student days, when my work most often consisted of nonobjective painting influenced by Wassily Kandinsky and Stuart Davis, things went just as slowly as they do now. At Yale in the late 1950s, when I was working with Josef Albers, I was developing a sense of art as gestalt—a concept of unity where abstraction was the most appropriate approach. I felt that I should strive in my work for an organism of shapes, lines, colors, and painterly gestures, whose interacting tensions would finally lock in a unified equilibrium. At Yale we referred to this balance of many parts as a "constellation."

If a painting achieves this unity, there will be for me a magical and haunting sense of serenity. The more the balance is arrived at through complexity, the more satisfying the ultimate serenity becomes. Recently I have had this sensation of poise amid motion with equal exhilaration before a painting by Willem de Kooning and a full-figure portrait by Francisco de Goya.

I am now rather bemused that I took this as the ultimate lesson from my years with Albers. A fundamental dictum of Albers and the Bauhaus was that now-clichéd motto, less is more. I seemed to prefer another Albers dictum: in art, two plus two equals at least five.

Because my search for visual equilibrium needed a passage through its antithesis of chaos, I would at some point find myself stuck in the morass, with no promise of resolution in sight. My last painting before I graduated took the entire term and resulted in a Kandinsky-in-1913 affair, finally arriving at what I took to be serenity through adversity. But Albers came into my studio while I was in the middle of the muddle, studied my painting for a while, and said, "simpler, boy, simpler." "I thought you liked Dürer," I said to him, plaintively trying to win him back to complexity. But he had moved on.

This characteristic slowness in my ability to crystalize a visual idea has had a central place in determining my present

art. It became quite clear to me in the years after I had finished studying with Albers that I was never going to be able to speed up my ability to work through an idea. To justify this exorbitant work time, I felt I needed another level of meaning: maybe if I added issues of light, naturalistic space, and sense of place to the abstract elements, the time I spent would be easier to rationalize. By then, after a brief adventure with sculpture, I had already turned to etching, working in black and white, and with etching I turned from Kandinsky and Davis to landscape.

My images followed a sort of evolutionary process: they went from abstraction to landscape, then to landscape with figures, then to figures in urban settings. After my children were born, in 1963 and 1964, my work followed their development. When they reached adolescence, I turned to the generic subject of adolescence, which is, in a sense, the material for the series *Les Belles et la Bête*. Finally, it seems to me, my work is now synchronized with my own life, and it can contain and reflect my present personal and aesthetic preoccupations. I have added ever more layers to complexity and even gone so far as to invite a narrative level to my images—painfully aware, of course, of the risk that I have been drifting daily further away from Purity. The first law of contemporary art, which insists on the primacy of the surface, has always seemed rather limiting to

me, and my enduring fascination has been with the paradox of the picture-as-flat and the picture-as-illusion. To encounter only surface events in a picture or only three-dimensional illusion have both seemed to me equally futile. I see the fundamental adventure of picture making as existing in the tension of the two as simultaneous realities.

So finally I told myself that I was, by nature, so removed from the aesthetically correct tenets of contemporary art that I might as well go for broke.

The fact that I am preoccupied simultaneously with exact focus and with multiplicity informs my drawings quite as much as my prints. I have never been attracted by drawing as either a relaxed sketching medium or a display of draftsmanly virtuosity. In fact, I have so little regard for the preliminary drawings I make in trying to work out some initial idea that I typically draw on clear Mylar with a felt pen, a method that produces pieces much too awkward to display. In the end, I am so worn down by the trial-and-error process of my image making that it becomes my dearest wish to consign the drawings to total oblivion once an idea is worked through.

My use of clear Mylar developed out of my use of collage as the best tool for generating complex ideas. Mylar is a clear polyester sheet, similar to acetate. I often

start with an improvisation on Mylar of some large, airy space, usually derived from one or two architectural photographs. I combine this Mylar sheet with others on which I have made figure studies, often in various sizes to help determine scale.

In time, I will have a complex collage of many sheets of overlapping Mylar, depicting an elaborate and spacious figure-filled environment. Typically, I will not have produced a single drawing that I find arresting enough to retain for its own sake, and eventually even the collage is dismantled.

But first I prepare a new sheet of Mylar by covering it with a very fine field of randomly placed India ink dots. I discovered that if I brush a mixture of India ink and sugar on a glass plate and then repeatedly place a sheet of paper over it and rub, a fine stipple texture builds up; this can be transferred to the Mylar sheet. The means of drawing with this tonal texture consists of flaking off the loosely adhering ink particles to make the lights and adding pen-and-ink spots for the darks, using the random texture itself as a middle gray. The particular fine graininess of this textural field, together with my natural proclivities for the meticulous, lends a strong photographic quality to my drawings. Considering my intense effort to keep the touch of the hand in everything, it is, to put it mildly, less than gratifying to find

myself sometimes classified as just a photoengraver.

When the sheet of Mylar has been prepared, I start a new drawing on it, using the collage as a reference. These Mylar drawings seem to be the best nonmechanical means for me to develop further the ideas from the collages. They give me a format that can be transferred directly onto a copper plate, using procedures that I can carry out in the studio without outside assistance. I draw on both sides of the Mylar, usually using one side for the linear elements of the image and the other for texture.

I love the quality of these drawings for their own sake, but I never intended to exhibit them until Gene Baro persuaded me, in 1980, to have a drawing show at the Brooklyn Museum, where he was consulting curator.

I first started using graphite on drafting film in 1976–77 with a group of preliminary drawings for the series *Les Belles et la Bête*. Drafting film is a clear Mylar sheet with a fine translucent granular surface added either to one side, which I prefer, or to both sides. When drawn on with very hard graphite leads, it is particularly sensitive to a delicate, precise touch and registers the slightest variation. I really take to this medium and feel its luminosity and responsiveness are unparalleled.

The drafting-film drawings for *Les Belles et la Bête I*, 1976, and *II*, 1977, became the

basis for the two ink-on-Mylar drawings that were transferred onto copper in 1977 for *The Rehearsal* and in 1978 for *Before the Hunt*. And the drafting-film *Belles et la Bête III*, 1979, was the source for the large oil painting also called *The Rehearsal*, 1984 (in the collection of the Currier Gallery of Art in Manchester, New Hampshire).

The seductiveness of drafting film led me to concentrate exclusively on drawing in 1980–81. Also, by the late 1970s, when I was doing the *Belles et la Bête* prints, I found myself increasingly dismayed by the secondary status of printmaking. The ubiquity of the element of collaboration, dismaying to anyone who searches out a singularity of vision as the ultimate artistic enterprise, particularly disconcerted me in contemporary printmaking—where the icons are as likely as not to be the creation of a painter who requires the services of a whole other talent, the master printer, to get the final image to happen at all, and where the products tend to be identified as much with a workshop as with an individual artist.

Previous to this period of my life I had felt curiously indifferent to the foibles of the art world, being mainly grateful that no one was bothering me. But I was approaching fifty and the midlife demons were mocking. Did the reliability of my slow but regular print output and its good public response mean that I was playing it too safe? I tended to forget the absurd

struggle entailed in resolving each image and started questioning the ease with which the image was accepted once the struggle was finished.

I suppose I needed a penance for whatever success the prints were bringing me, or at least proof that bounty and prestige had not been their prime objective. I consciously determined to find a direction that would put my acceptance at risk, and pursued a thread that had already appeared in the two *Belles et la Bête* prints. With my penchant for the iconographic and the mnemonic, an affectionate and gentle erotica suggested itself—something at the opposite pole of the contemporary mode. I see my erotic drawings as almost a wistful valediction to the freedom granted by innocence, and therefore being as likely to put off those who partake of the current taste for shock, rawness, and iconoclasm as to offend some of my—up to now—faithful collectors.

Perhaps the seductiveness of the drafting-film medium was a reason that my imagery became so involved with seduction as subject, and I wonder if the medium's purity and delicacy did not also determine the subject. If seduction was leading to matters sexual, I was finding that the luminosity of the medium, the delicacy of touch it was making possible, allowed me to go much further than I

would ever have thought possible—even to the point of outrageousness without stepping beyond the bounds. Everything had a curious air of innocence no matter where I took it.

What had started as a resolute determination to take risks ended up as a fête galante. I was relieved and buoyed up by what this aspect of the human equation was opening up for me as an artist. It seemed an artist was the luckiest of people that he could plunge into a reckless midlife romp and make trouble for no one. Furthermore, he could pass on its pleasures to others.

In my mind I call the whole series "Stolen Moments." One image from 1980, actually titled *Stolen Moments*, is possibly the most outrageous of them all. Two dancers in some kind of rehearsal are so carried away with each other that they simply cannot wait. The man may be part animal, or just masked as one. Dancing, floating, swimming, embracing are all images of liberation. A freeing from the physical constraints of gravity suggests a freeing from the constraints of the psyche. I like the dog in *Stolen Moments*. His good cheer and exuberance made the whole image possible for me. But in *Io and Jupiter*, 1980, the dog takes on a hint of the sinister, and in *Friends*, 1981, he reverts to outright snarls and barks. In later and darker drawings,

menace becomes the prevailing canine attribute. The fête is over.

The drawings *Io and Jupiter* (second version), 1982, and *Les Belles et la Bête III*, 1980, are atypical. They are drafting-film drawings that have been contact-printed onto Cronaflex—a photographic film similar in surface and translucency to drafting film—then further developed with pencil and crayon. Alas, the original *Io and Jupiter*, as mortal as the nymph from whose myth it draws, has been involved in a fire and probably lost. The reproduction here is from a Cronaflex.

After my *Stolen Moments* excursion, I spent the year of 1983 developing the *Belles et la Bête III* image as an eight-foot painting. It soon became painfully evident again that I was not going to be able to work any faster than one painting a year. The prospect of taking a decade to produce a full show of paintings indicated persuasively the wisdom of returning to prints, where at least a year's work would mean providing images for a variety of venues rather than the possibility of providing a white elephant for none.

The next group of drawings, seven ink-on-Mylar pieces made between 1984 and 1991 for the *Interiors* intaglio series, marked my return to printmaking—which was a somewhat nerve-racking affair, since I had to feel my way back into the elaborations

of prints after the simpler *Stolen Moments* cycle. I had no thought of a series at first, and I started on *Family Reunion,* 1984, with the idea of dividing it into two prints. *Family Reunion* established the themes for the entire series: a central figure lost in thought, surrounded by fragments of that thought; increasing suggestions of self-portraiture; the theme of two women that appears again in *Stolen Moments* and *Time with Celia,* both 1986; the large, evocative public space. These spaces, hushed at first, become more and more clamorous. *The Train from Munich,* 1991, the last drawing of the series, ties down the hints of allegory and personal iconography of the earlier pieces and distills them specifically into the century's most intense and grimly defining moment: fascism's rise in Europe and its apotheosis into the Final Solution.

Interior with Small Head, 1967, graphite and ink wash on paper, 30 x 22 inches. Mr. and Mrs. Edwin Miller, Riverdale, New York.

The Jolly Corner, 1969–71

FACING PAGE: Sequence I, Drawing #1, ink on Mylar, 20 x 26 inches

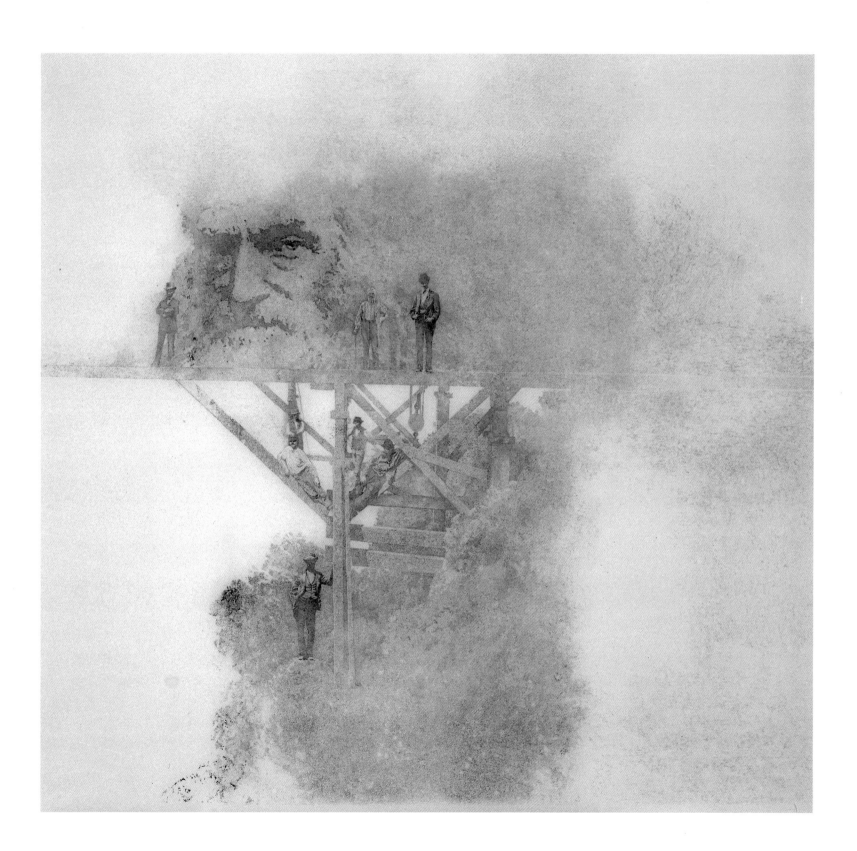

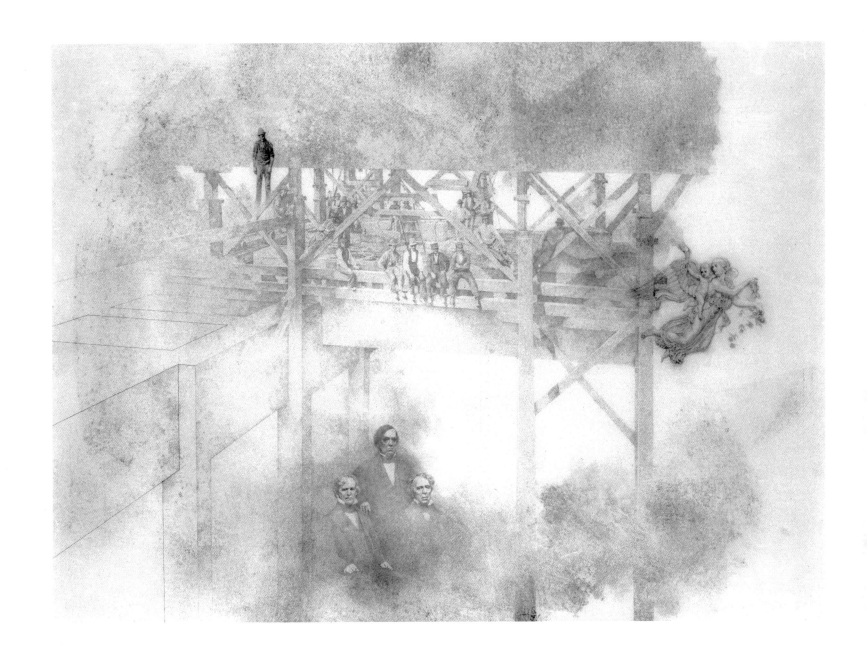

Sequence I, Drawing #2, ink on 3 sheets of
Mylar, 20 x 25 inches.

Sequence I, Drawing #2, detail.

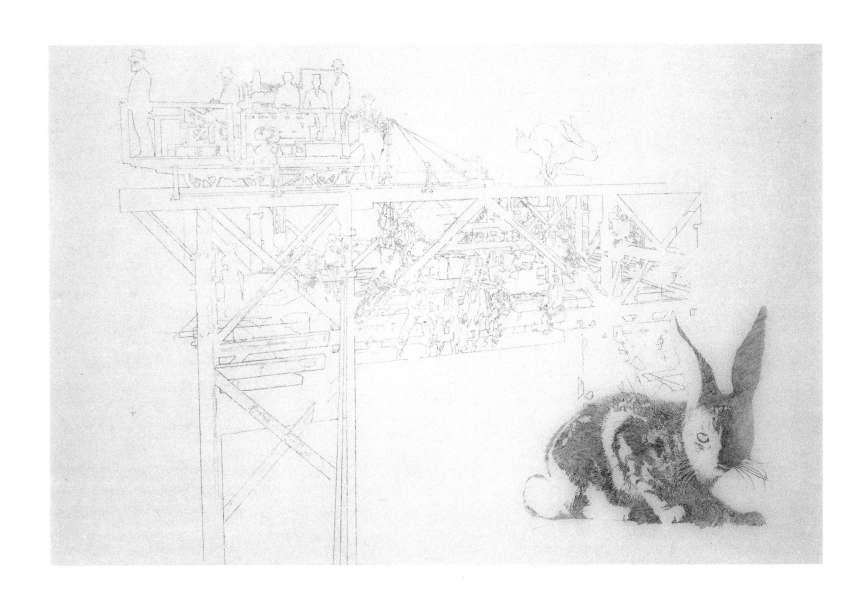

Sequence I, Drawing #3, ink on
2 sheets of acetate and 1 sheet of Mylar,
16 x 22 inches.

24

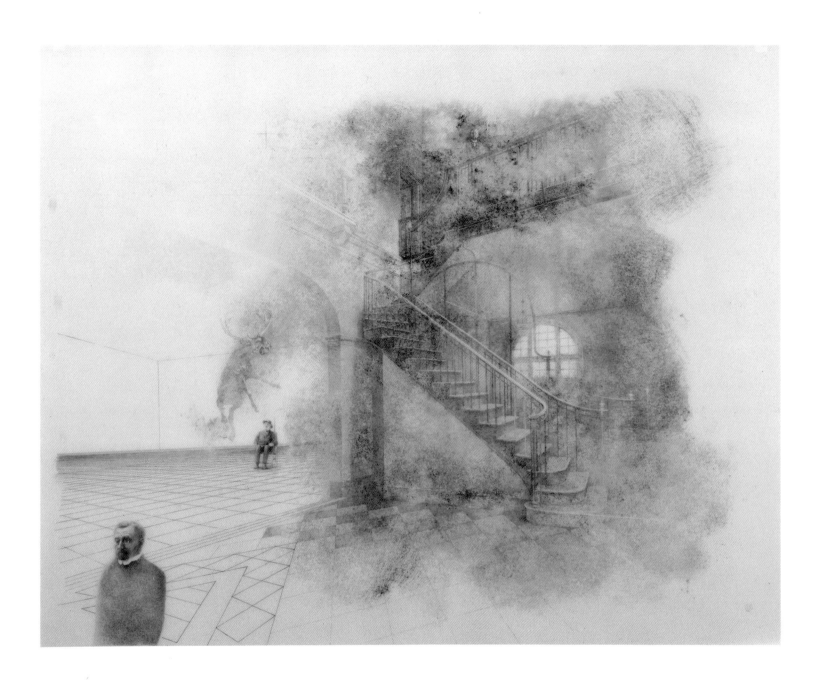

Sequence II, Drawing #1, ink on Mylar,
20 x 26 inches. Stephen Bosniak,
New York.

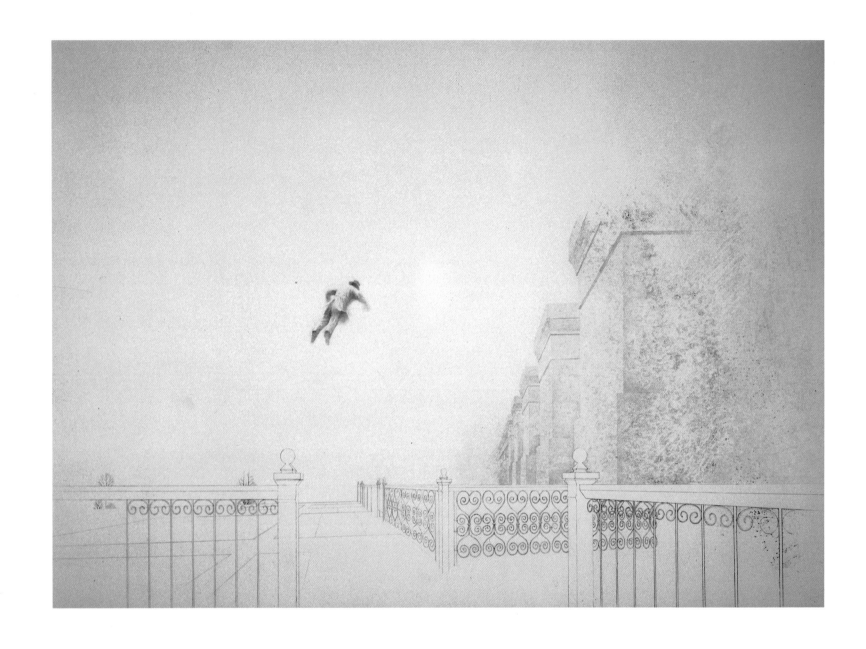

Sequence II, Drawing #2, ink on 2 sheets
of Mylar, 20 x 25 inches.

26

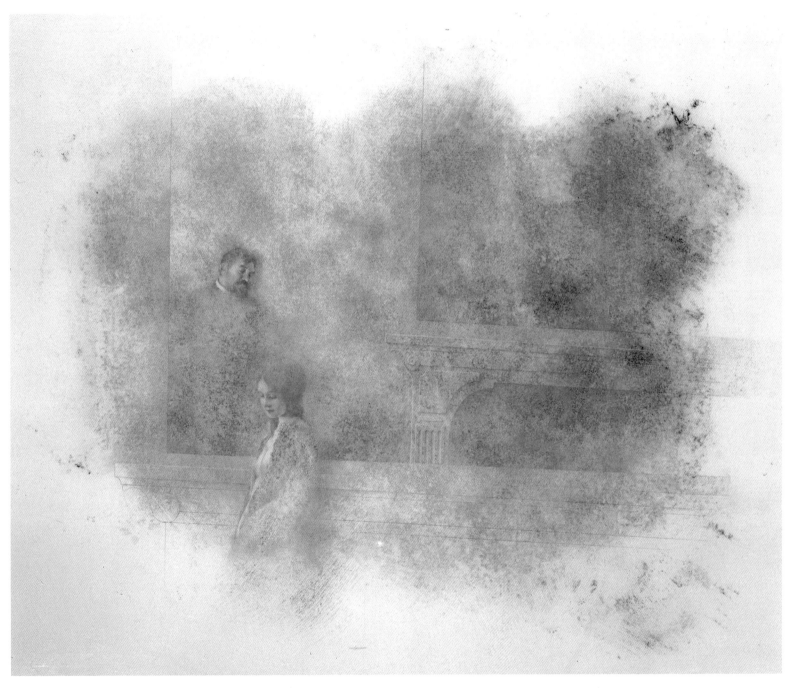

Sequence III, Drawing #1, ink on Mylar,
20 x 26 inches.

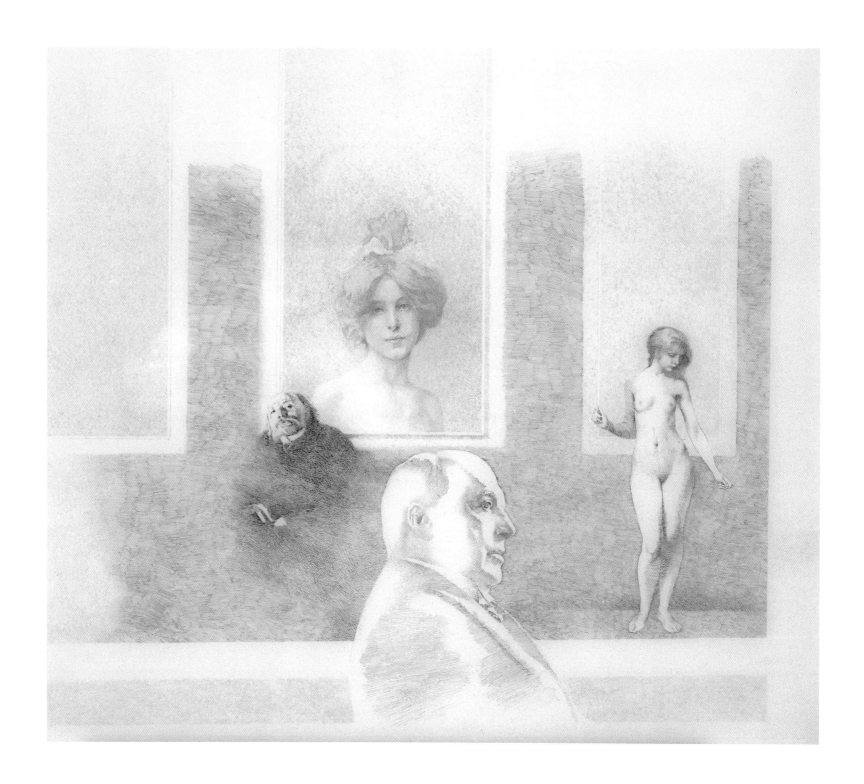

28

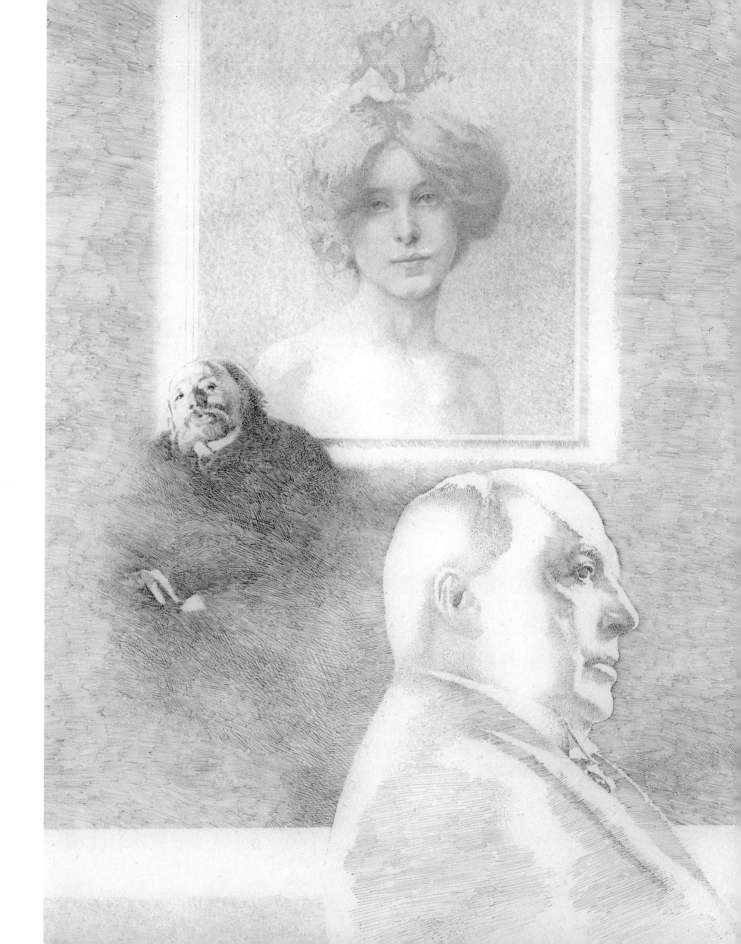

FACING PAGE:
Sequence III,
Drawing #2,
ink on Mylar,
20 x 25 inches.

THIS PAGE:
Sequence III,
Drawing #2,
detail.

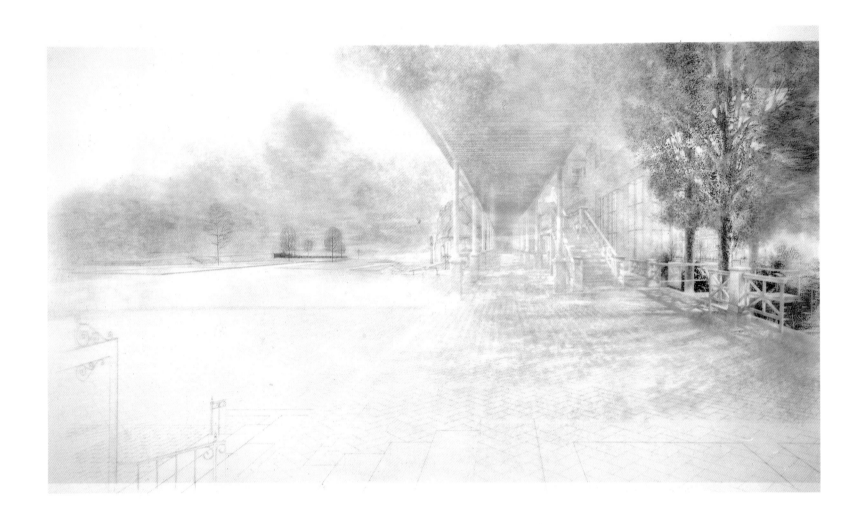

Passage: Icarus at Marienbad, 1971, ink on
Mylar, 27 x 47 inches. Colonel and Mrs.
Kenneth S. Hitch, Washington, D.C.

Small study for *Sky Blue Life*, 1976, ink on Mylar, 8 x 12 inches.

Small study for *Passage III*, 1972, ink on Mylar, 10 x 13 inches.

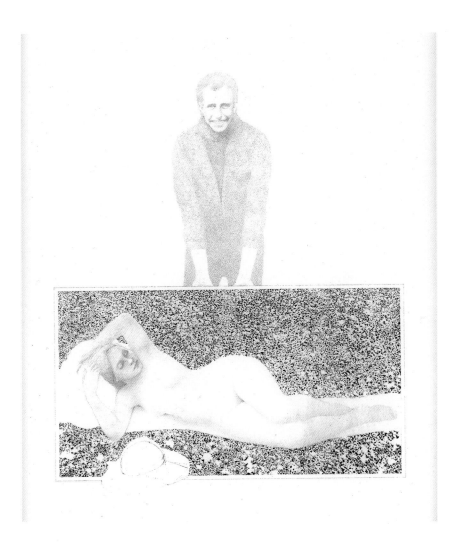

Small study for *Collecting*
with Rudi, 1974, ink on Mylar,
10 x 8 inches.

Small study for *Collecting*
with Rudi, 1974, ink on Mylar,
10 x 8 inches.

32

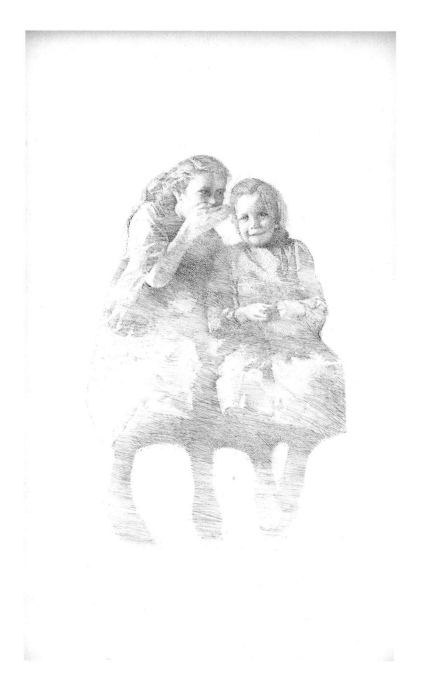

Small study for *Collecting
with Rudi*, 1974, ink on Mylar,
10 x 8 inches.

Small study for *The First Gate*,
1974, ink on Mylar, 10 x 8
inches.

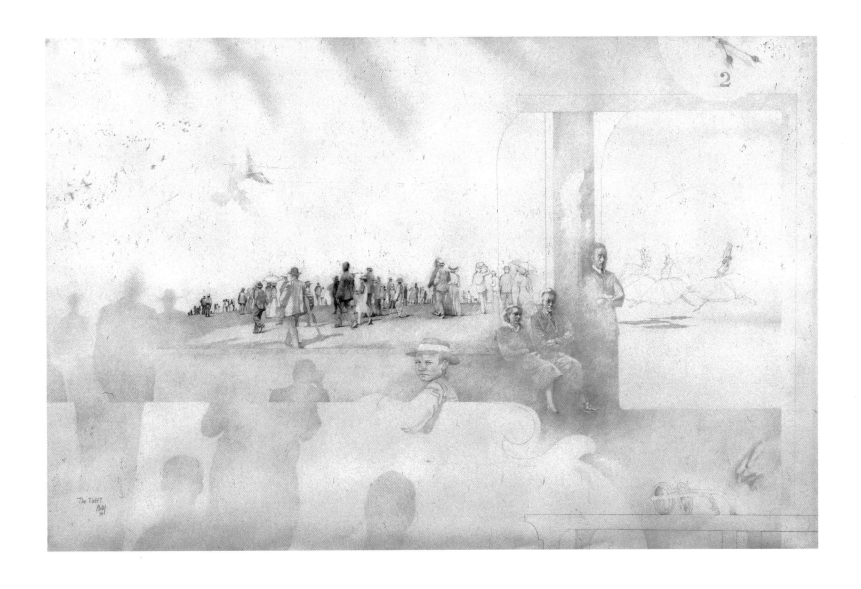

The Theft, 1974, graphite on paper, 26 x 40
inches. John and Sabina Szoke, New York.

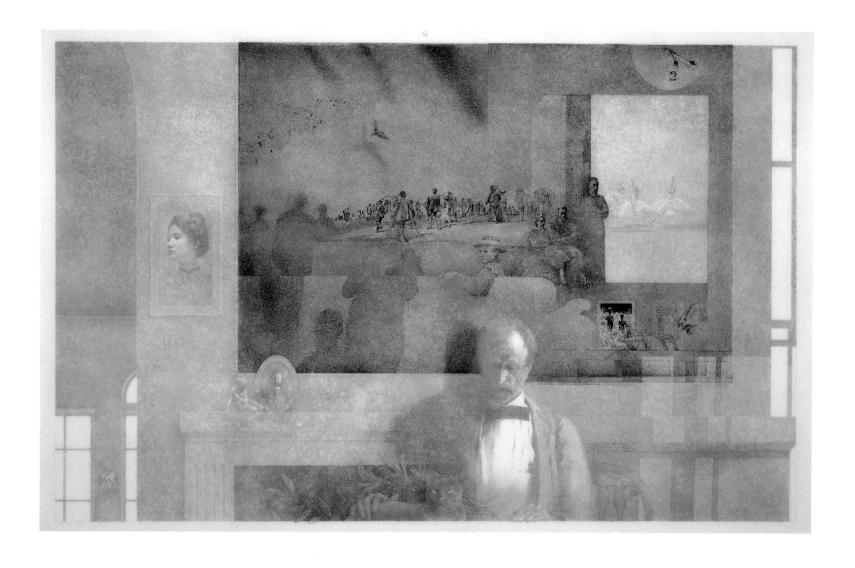

Daylilies, 1974, ink on Mylar with collage,
20 x 32 inches. Museum of Art, Rhode
Island School of Design, Providence.
Purchased with the aid of funds from the
National Endowment for the Humanities
and Mr. and Mrs. Gilman Angier.

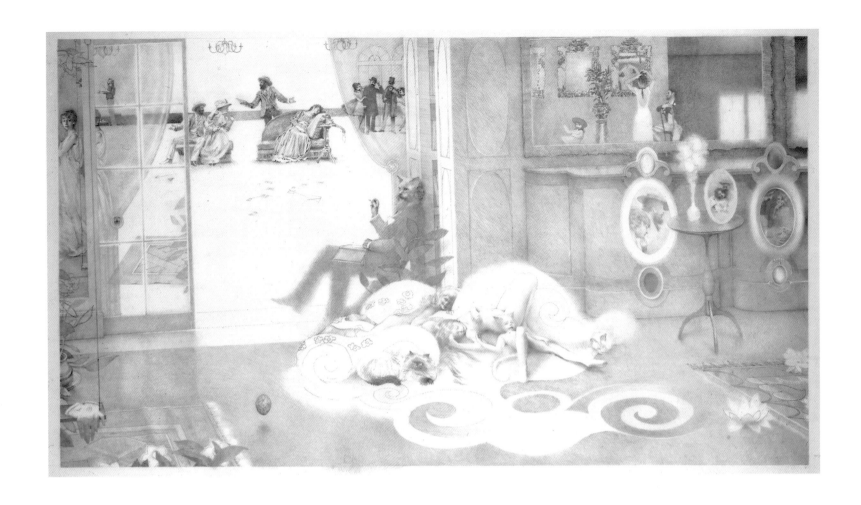

Study for *Les Belles et la Bête I*, 1976, graphite
on drafting film, 24 x 40 inches.

FACING PAGE: Study for *Les Belles et la Bête I*,
detail.

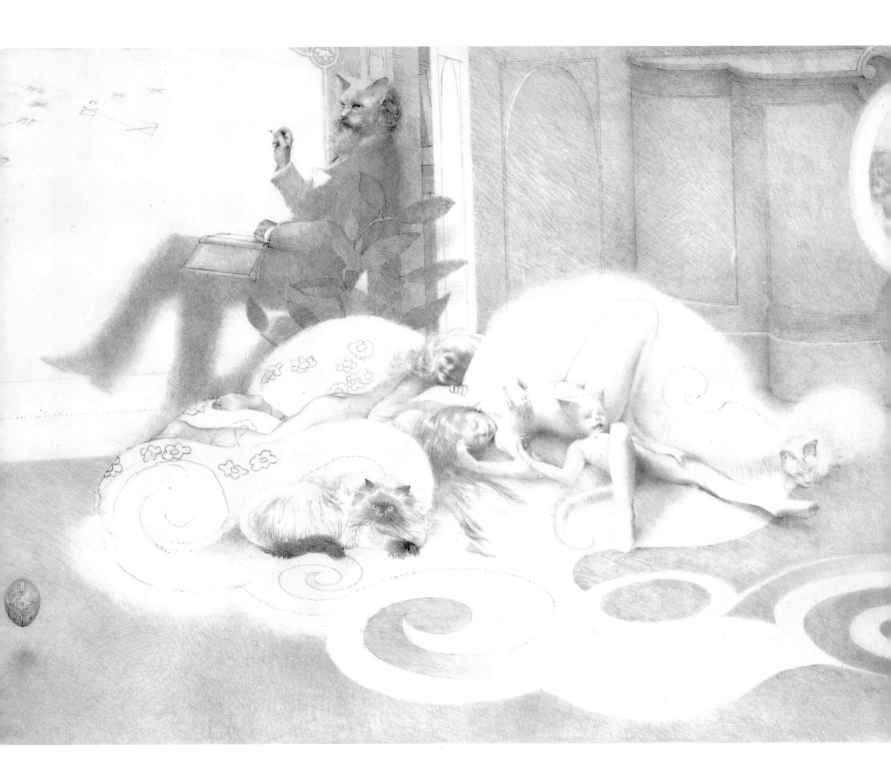

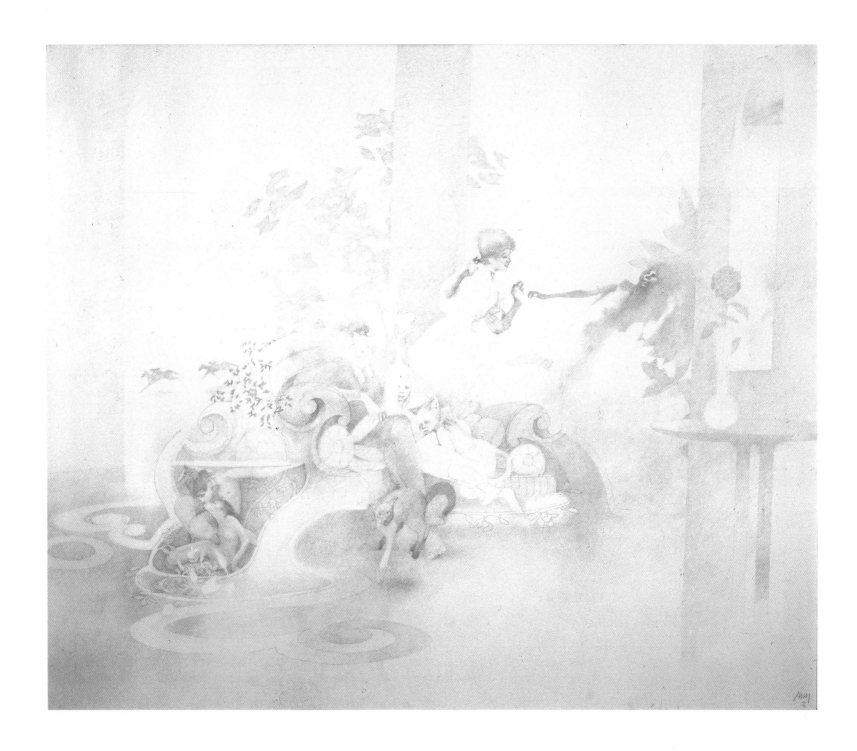

38

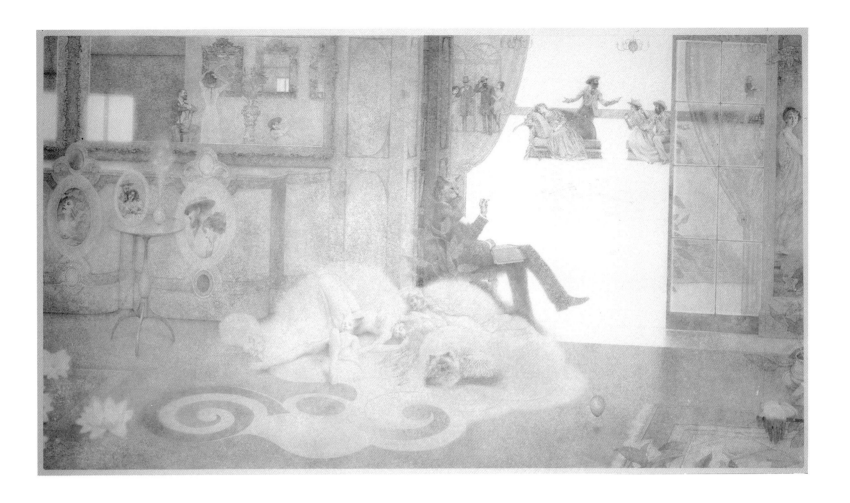

FACING PAGE: Study for *Les Belles et la Bête II*, 1977, graphite on paper, 22 x 26 inches. Dr. and Mrs. Gerard Suskind, Washington, D.C.

Les Belles et la Bête I: The Rehearsal, 1977, ink on Mylar, 20 x 36 inches.

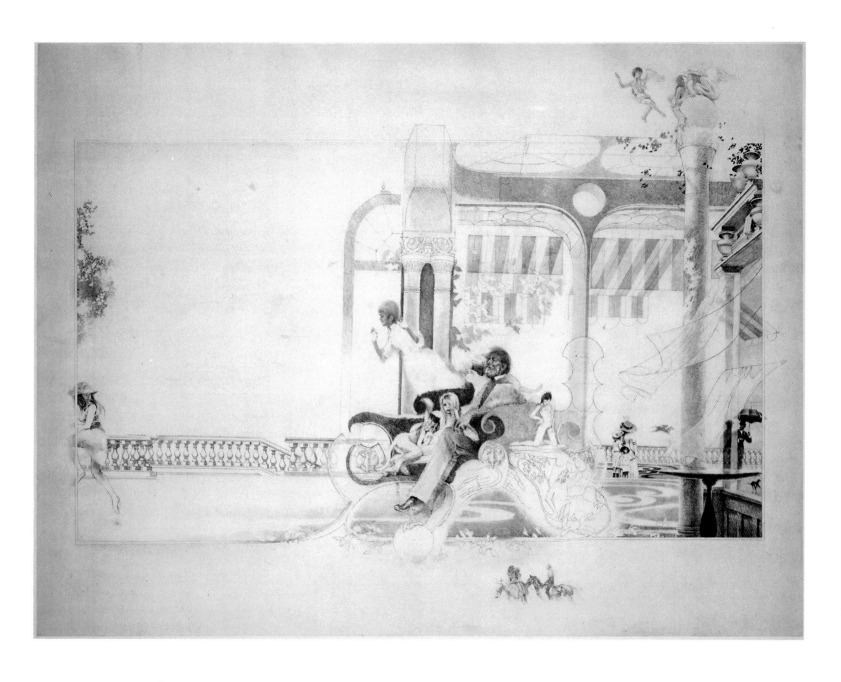

Study #1 for *Les Belles et la Bête II*, 1977,
graphite on drafting film, 30 x 40 inches.

FACING PAGE: Study #1 for *Les Belles et la
Bête II*, detail.

40

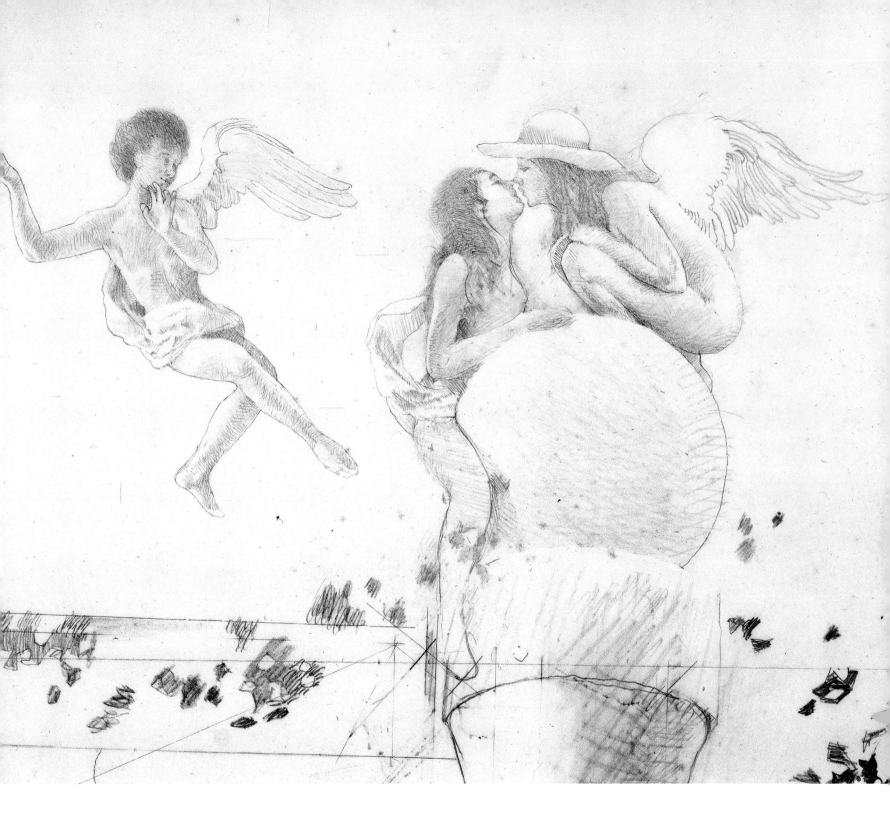

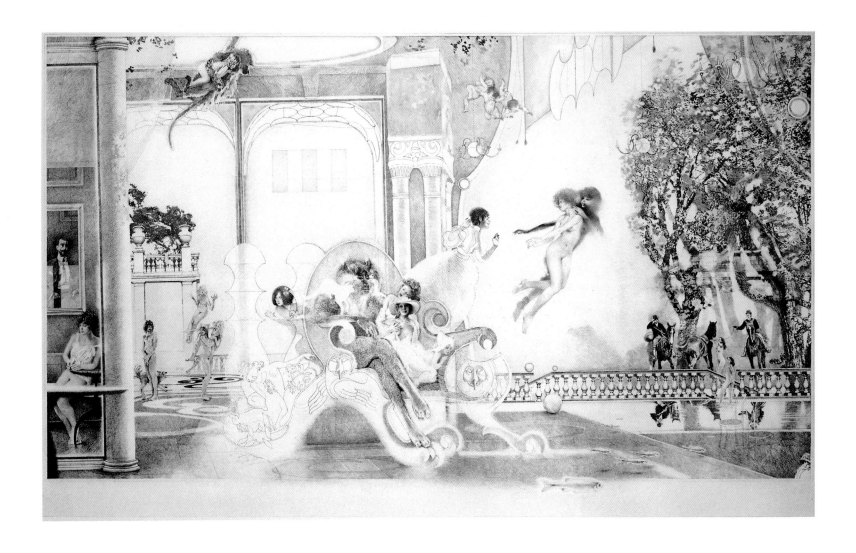

Study #2 for *Les Belles et la Bête II*, 1978,
graphite on drafting film, 25 x 41 inches.
Joel Moss, Los Angeles.

FACING PAGE: Study #2 for *Les Belles et la
Bête II*, detail.

42

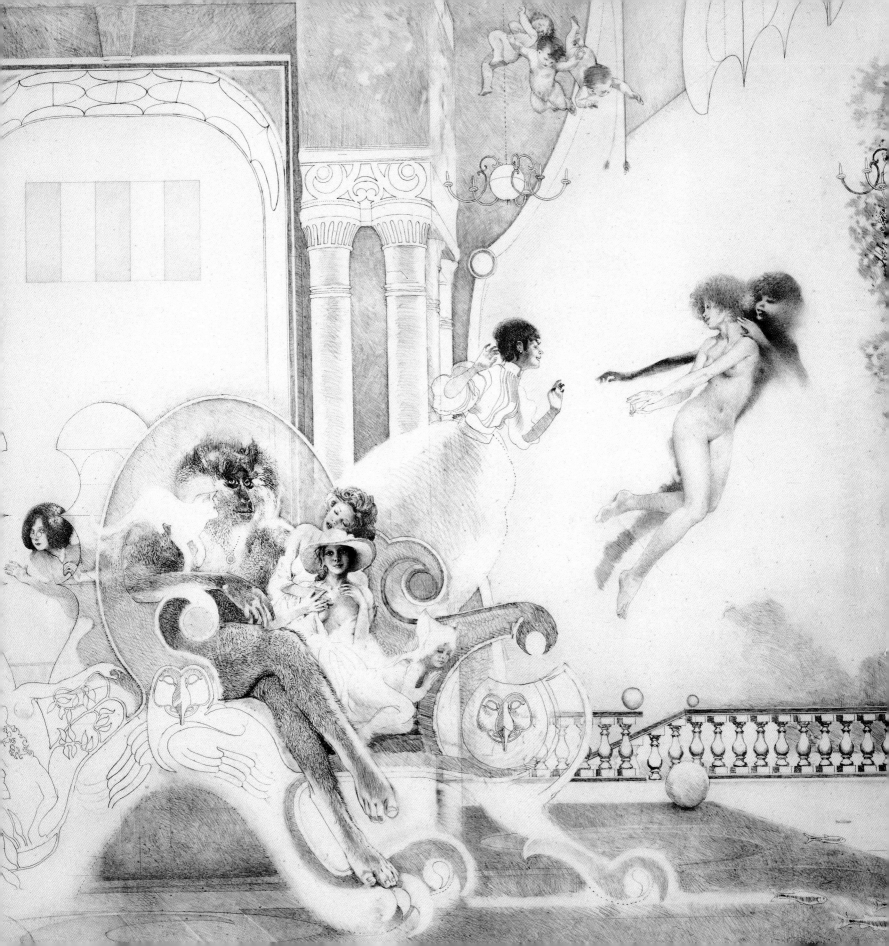

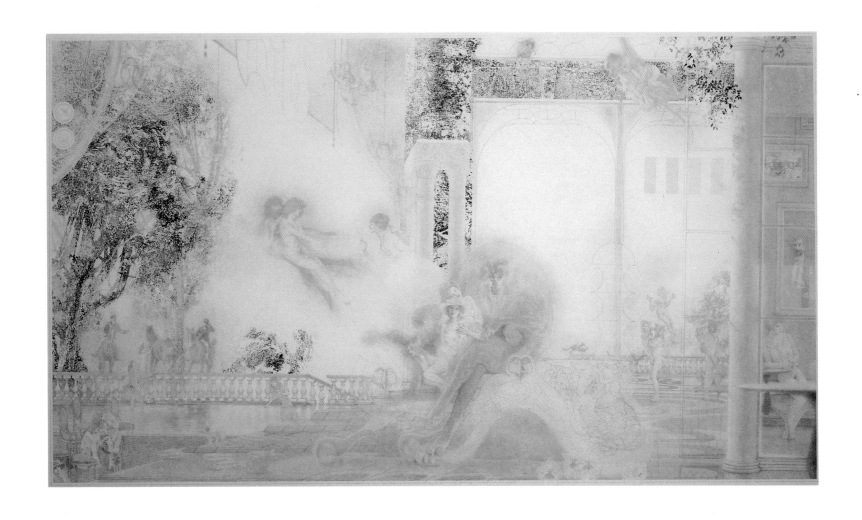

Les Belles et la Bête II: Before the Hunt, 1978, ink on
Mylar, 22 x 39 inches.

THIS PAGE: *Les Belles et la Bête II: Before the Hunt*, details.

FOLLOWING PAGES, LEFT: Study #1 for *Les Belles et la Bête III*, 1979, graphite on drafting film, 15 x 18 inches.

RIGHT: Study #2 for *Les Belles et la Bête III*, 1979, graphite on drafting film, 24 x 36 inches.

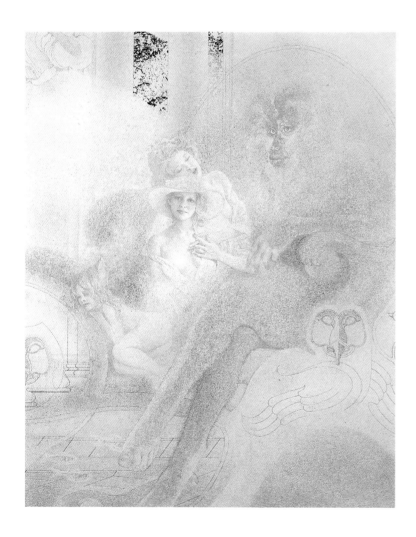

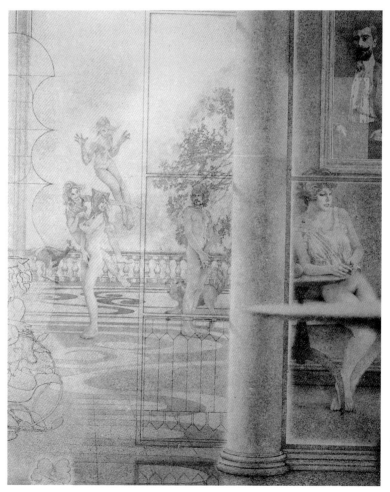

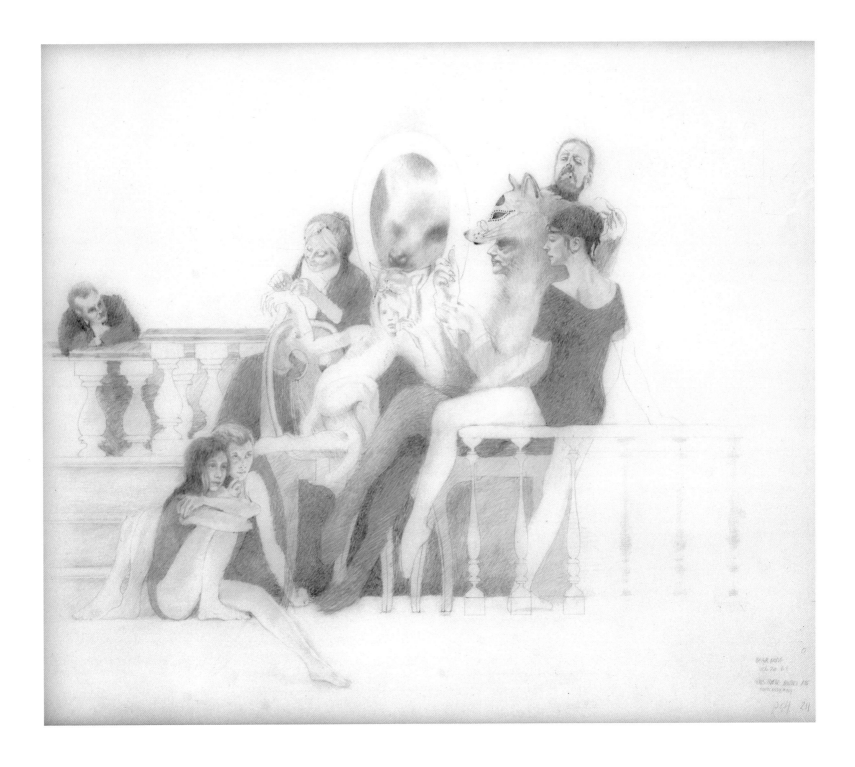

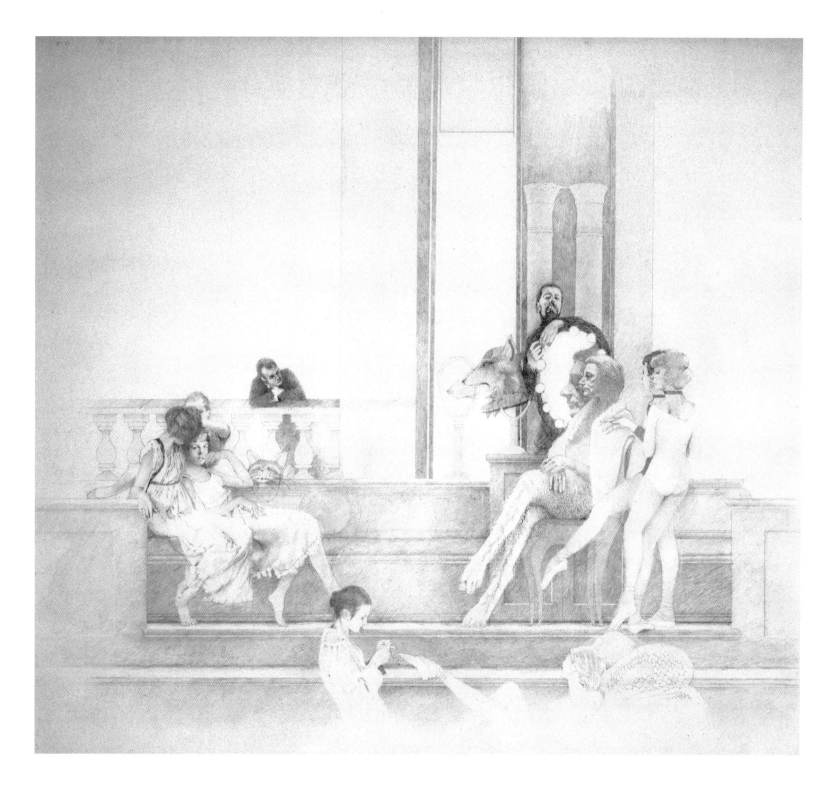

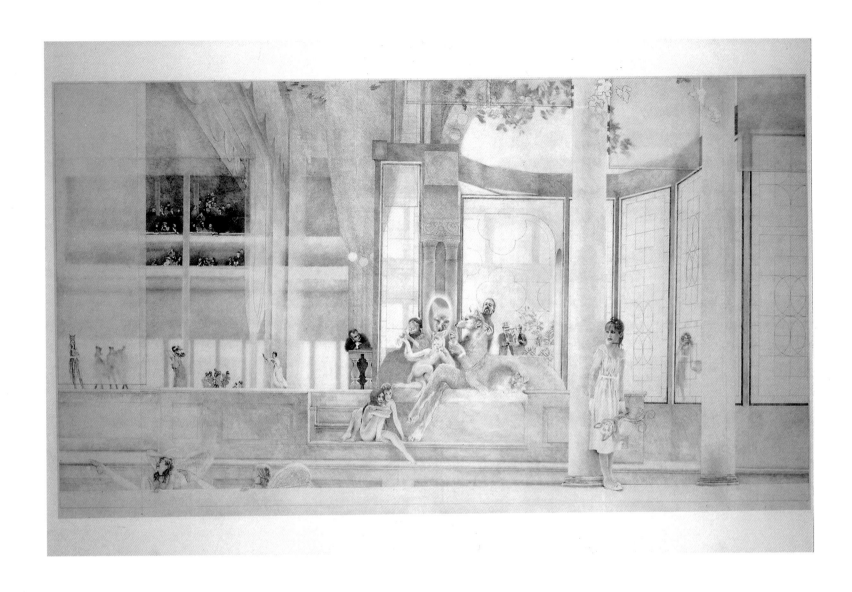

Study #3 for *Les Belles et la Bête III*, 1979,
graphite on drafting film, 30 x 54 inches.
Mr. and Mrs. Andrew F. Wiessner, Denver.

FACING PAGE: Study #3 for *Les Belles et la
Bête III*, detail.

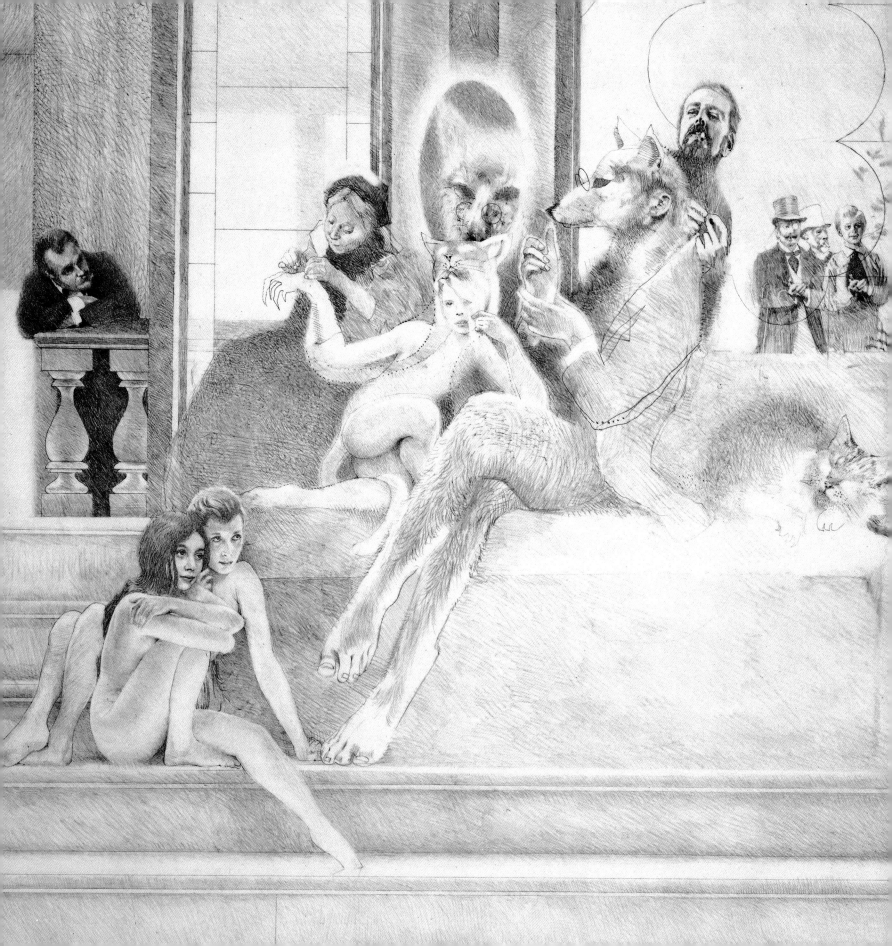

Study for *Country Pieces I: The Couple*, 1979,
ink on Mylar, 21 x 27 inches.

Study for *Country Pieces II: In the Park,* 1979,
ink on Mylar, 21 x 27 inches.

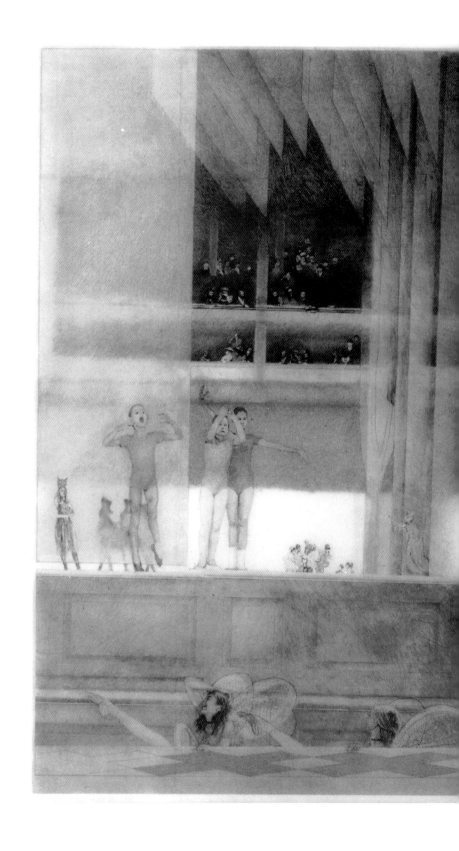

Les Belles et la Bête III, 1980, graphite and crayon on Cronaflex, 30 x 54 inches. Private collection.

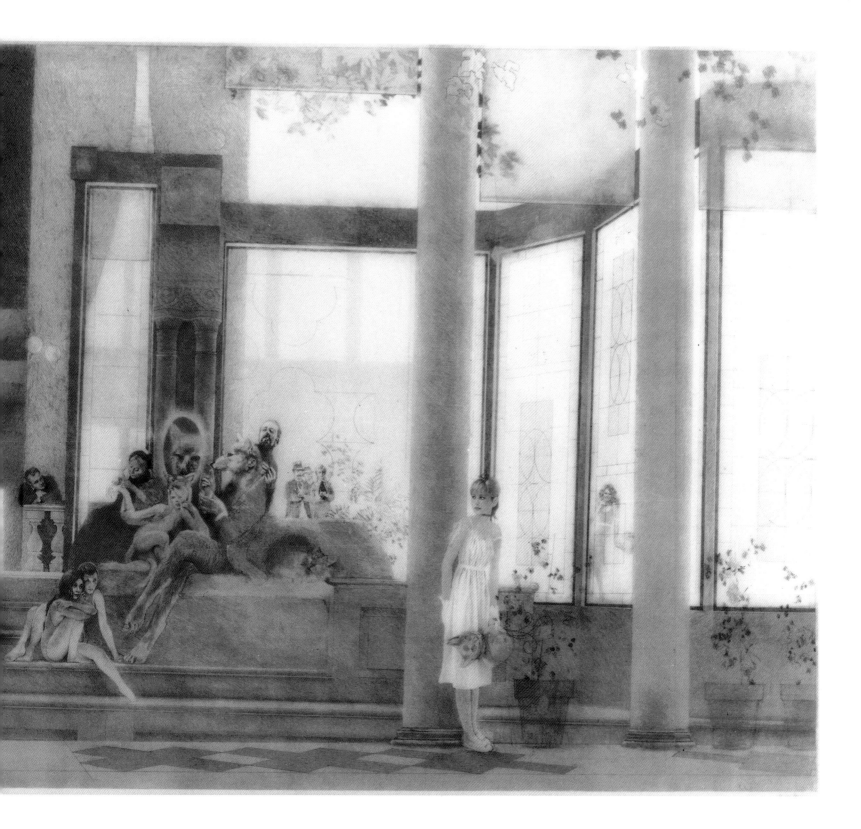

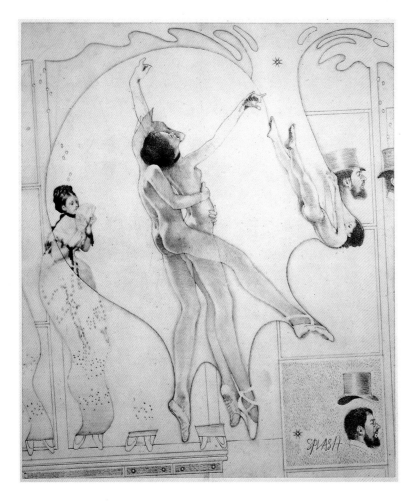 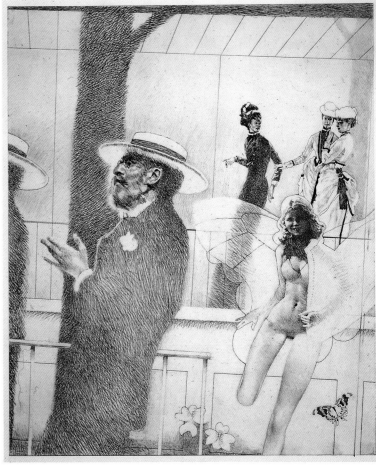

ABOVE: *Splash*, 1980, graphite on drafting
film, 10 x 8½ inches.

RIGHT: *Butterfly*, 1980, graphite on drafting
film, 9 x 7 ½ inches. Dr. and Mrs. Donald
Heyneman, San Francisco.

FACING PAGE: *Dancing Lesson*, 1980,
graphite on drafting film, 8½ x 10 inches.

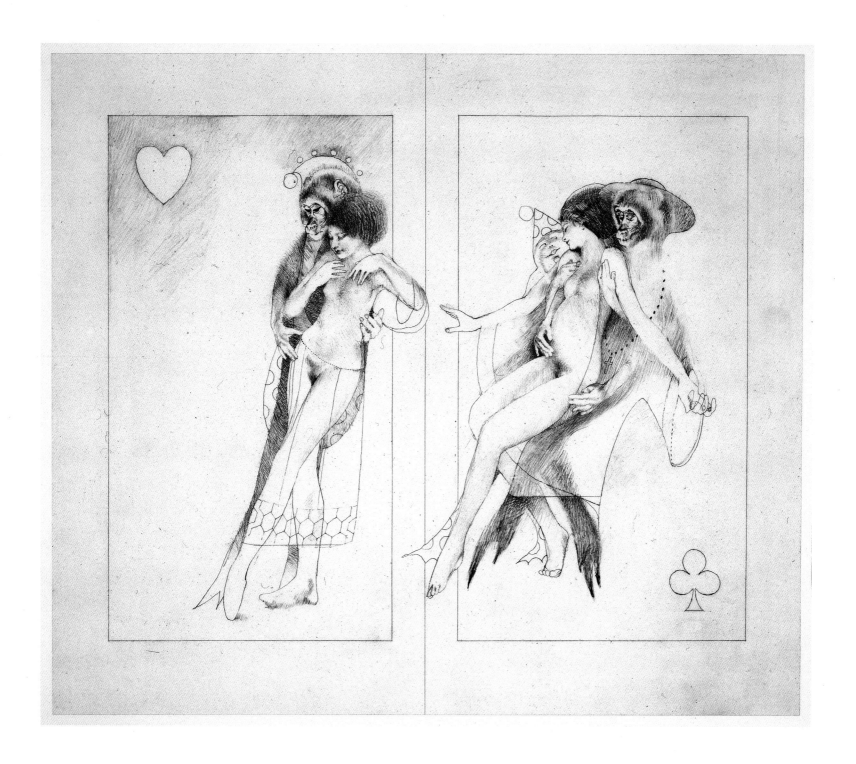

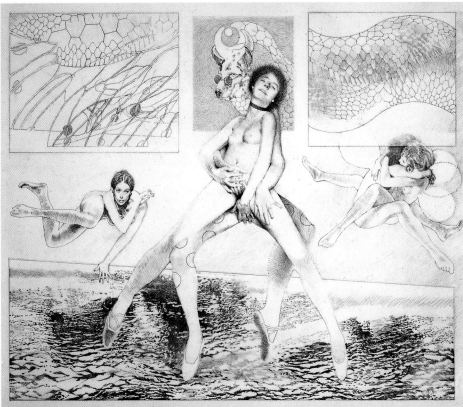

ABOVE: *Notes*, 1980, graphite on drafting film, 5 ½ x 8 inches. Dr. and Mrs. Donald Heyneman, San Francisco.

RIGHT: *Europa*, 1980, graphite on drafting film, 8 x 10 inches.

FACING PAGE: *Pas de Deux*, 1980, graphite on drafting film, 7 ¼ inches diam. Private collection.

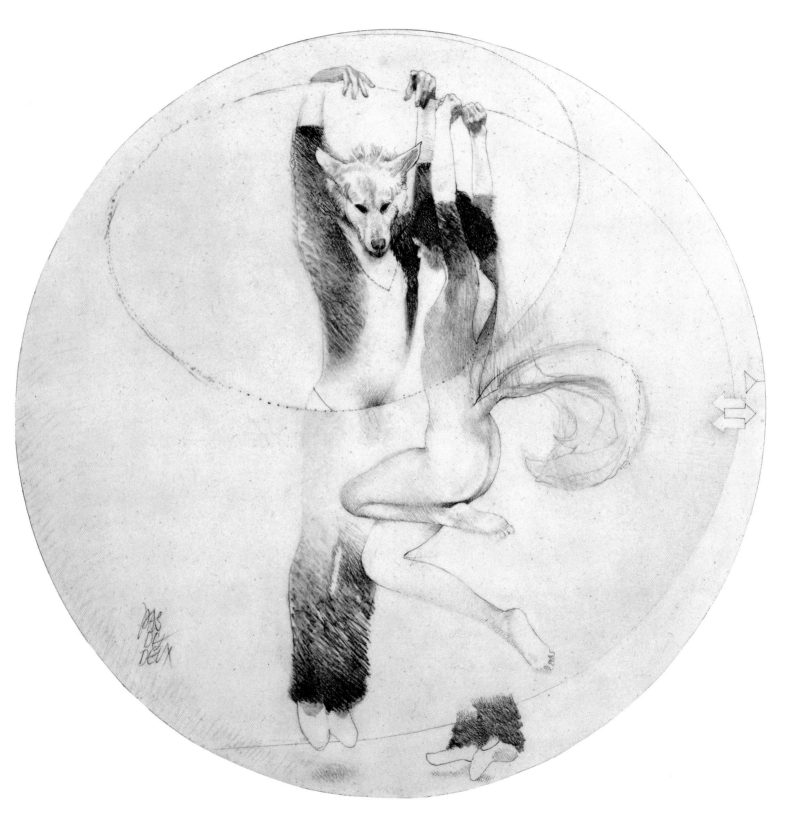

57

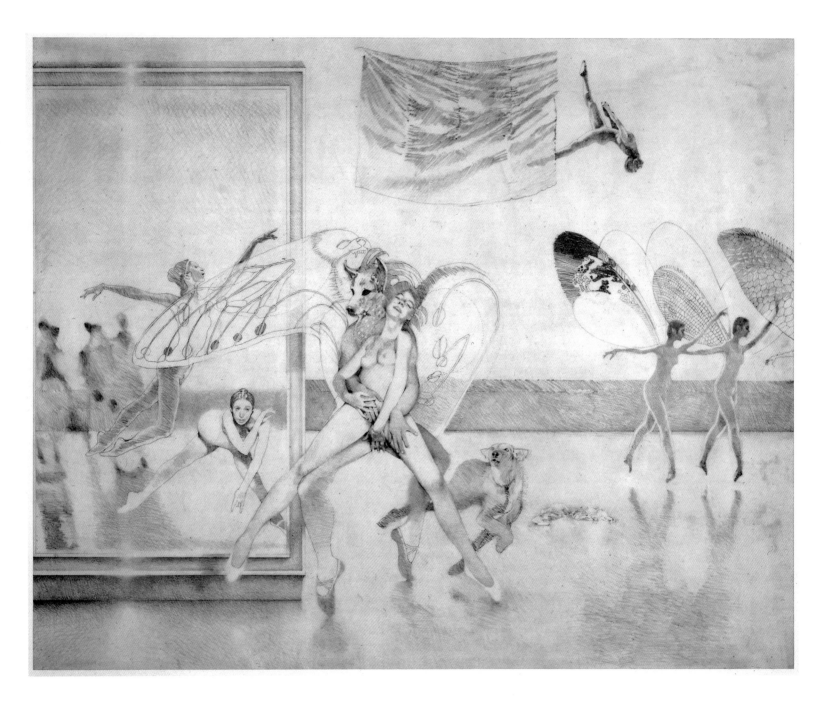

Stolen Moments, 1980, graphite on drafting film, 12 x 15 inches.
Mr. and Mrs. Andrew F. Wiessner, Denver.

FACING PAGE: *Stolen Moments*, detail.

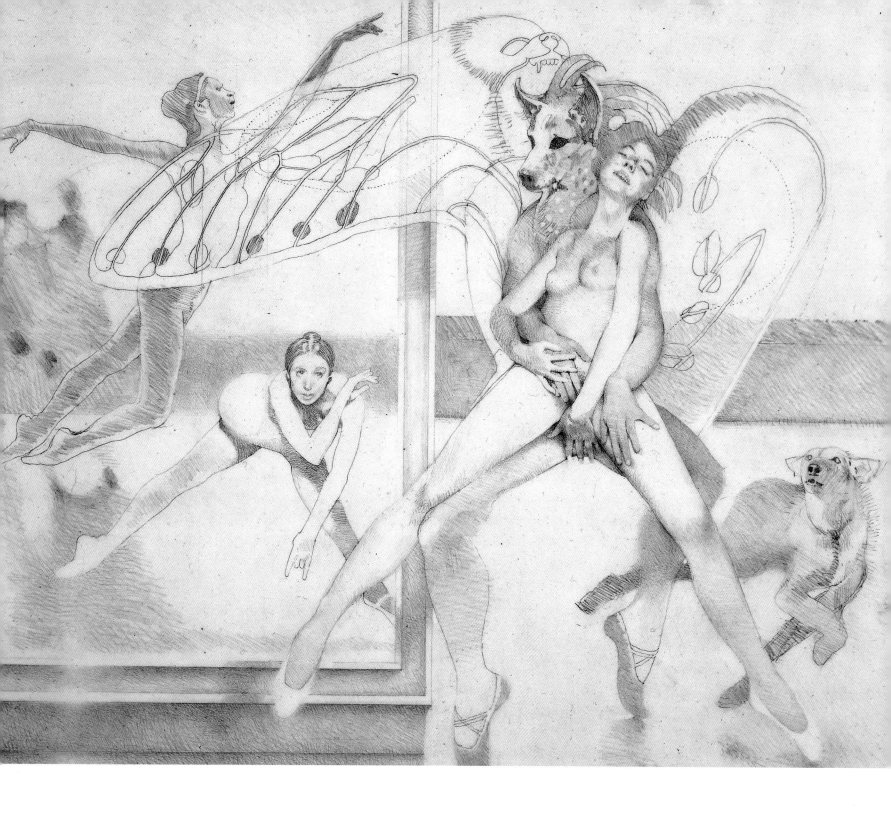

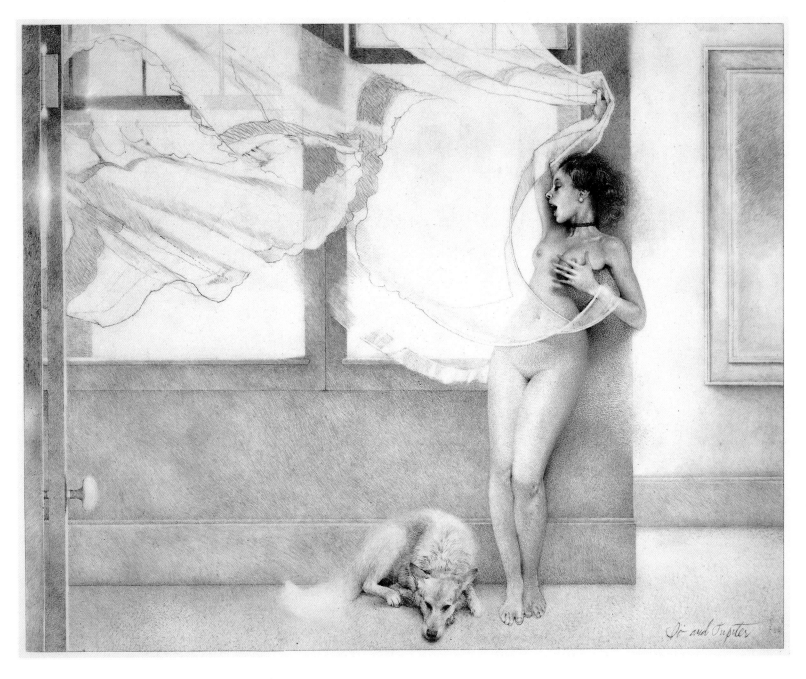

Io and Jupiter, 1980, graphite on drafting film, 8 x 10 inches. Estate of Dr. Lois Tice. (Possibly lost in a fire.)

FACING PAGE: *Inner City,* 1981, graphite on drafting film, 12 x 15 inches. National Museum of American Art, Smithsonian Institution, Washington, D.C.

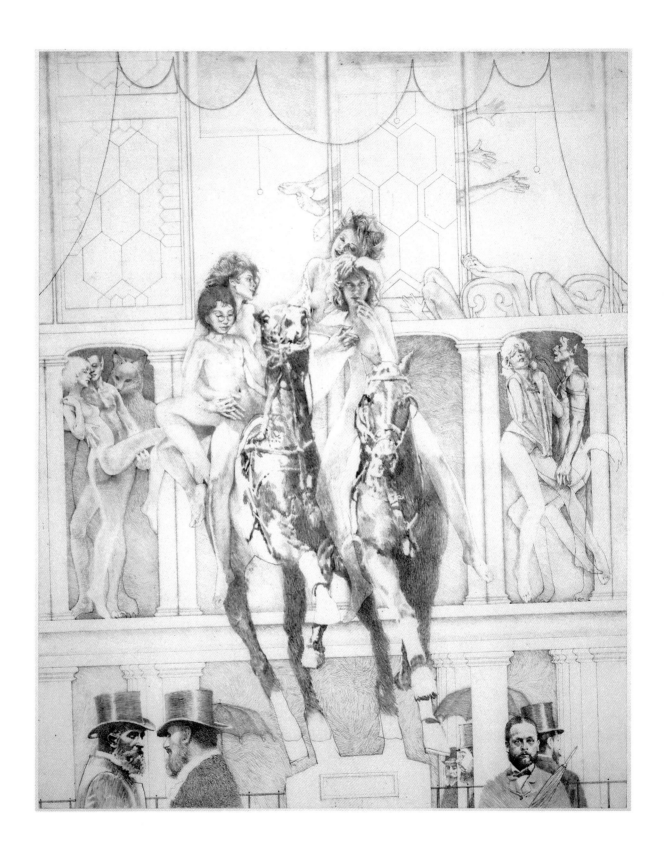

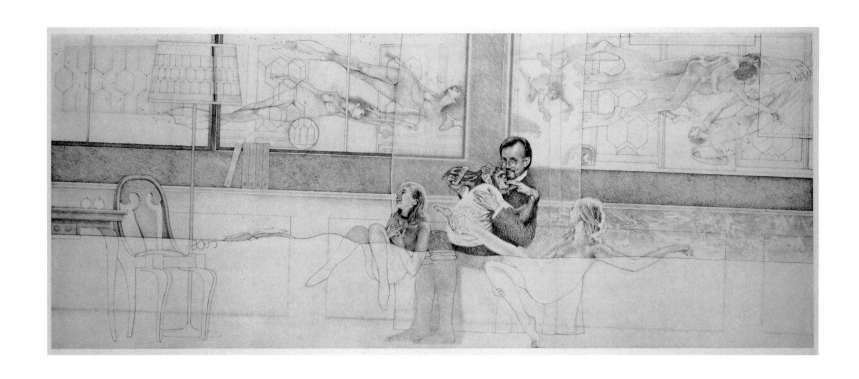

ABOVE: *Splash 1981*, 1981, graphite on
drafting film, 12 x 30 inches. National
Museum of American Art, Smithsonian
Institution, Washington, D.C.

FACING PAGE: *Splash 1981*, detail.

62

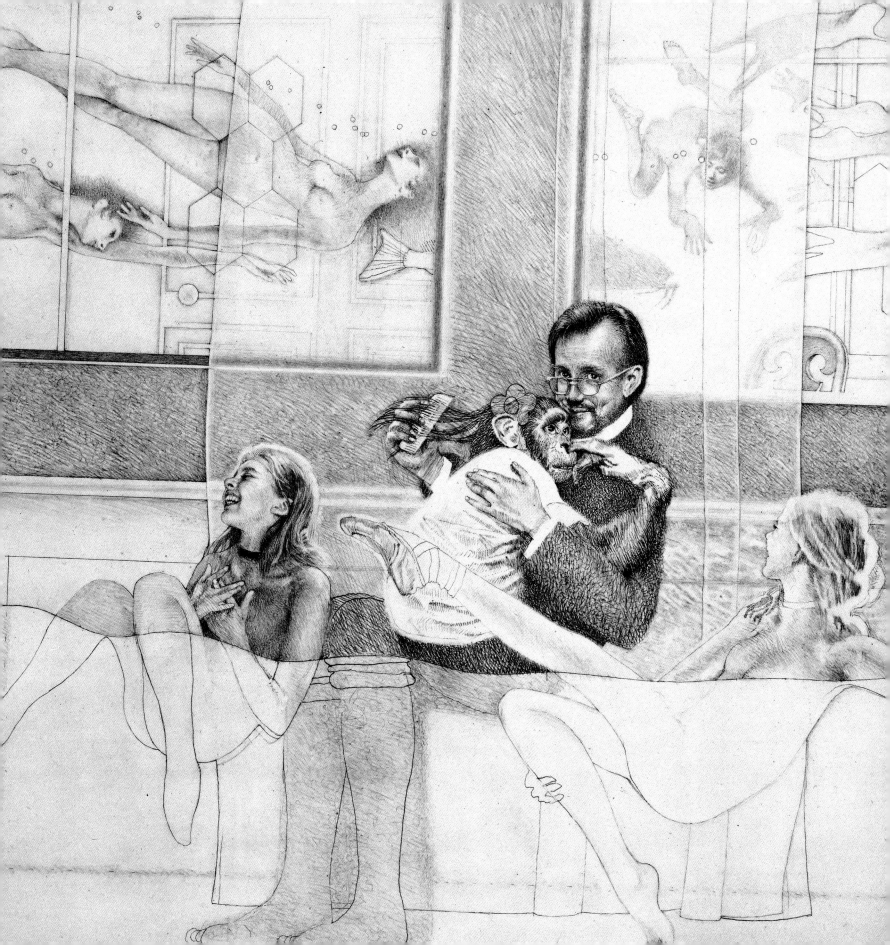

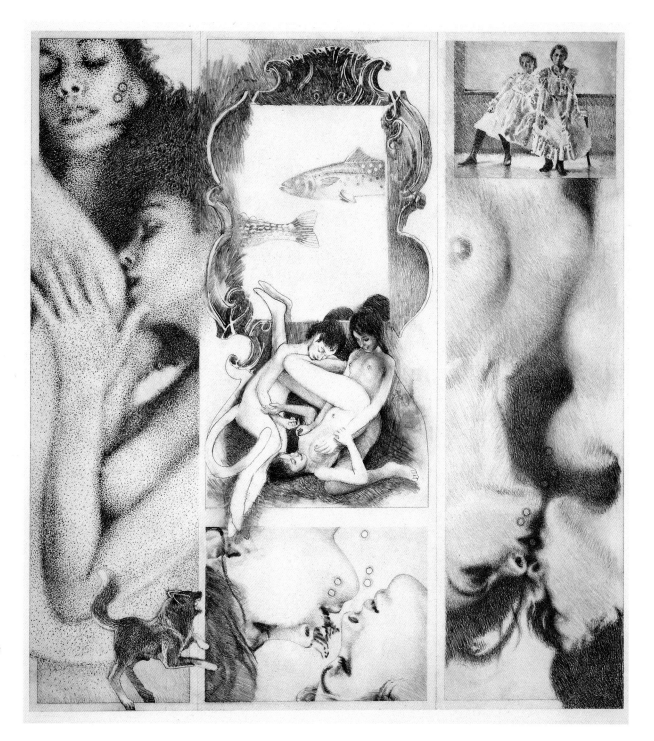

Friends, 1981, graphite
on drafting film,
9 x 10 inches.

FACING PAGE: *Friends*,
detail.

64

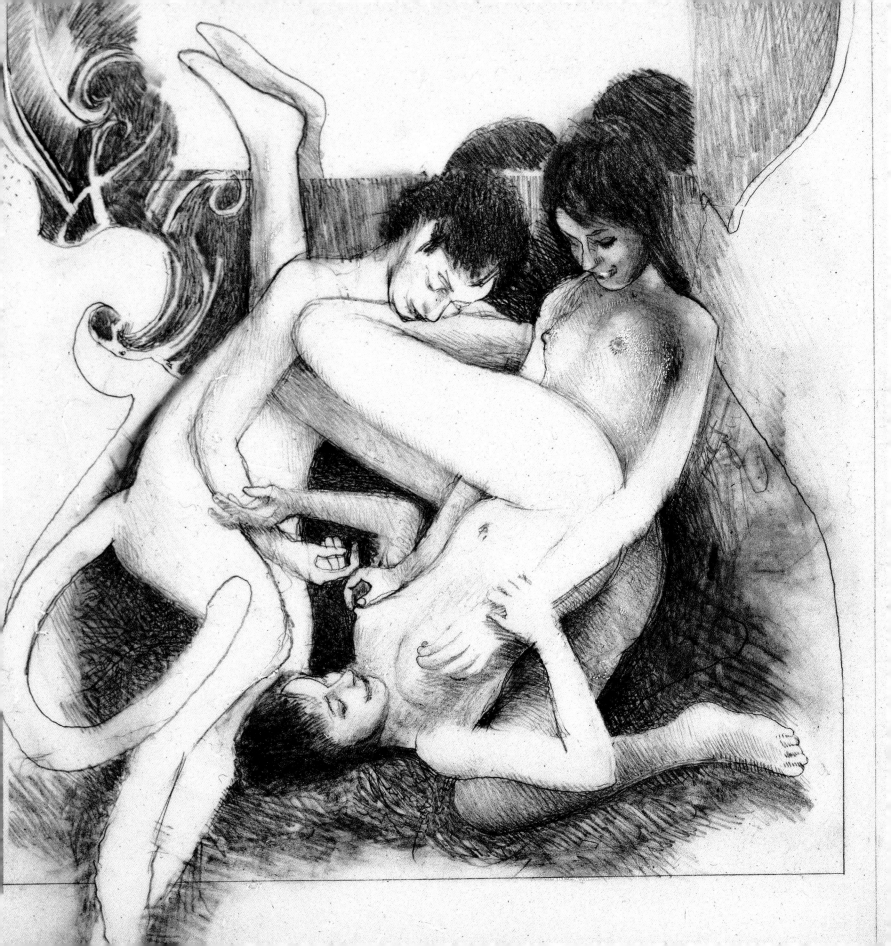

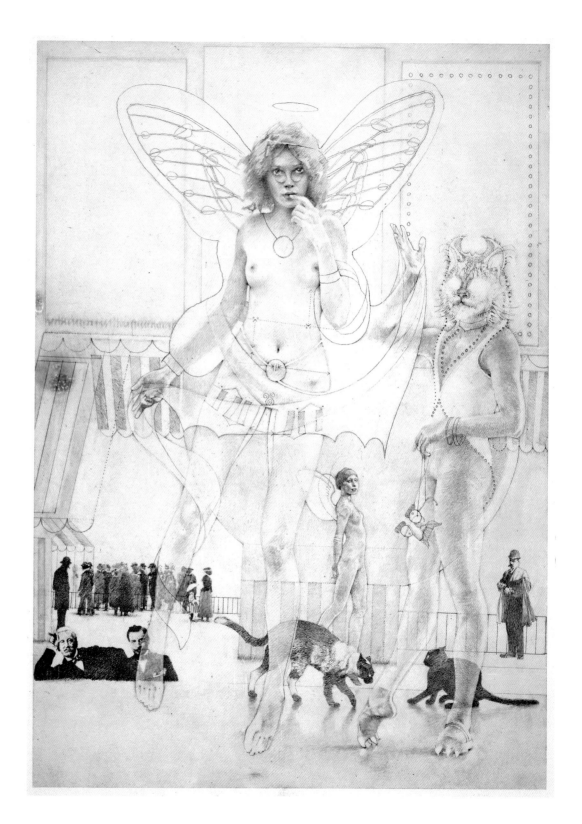

FACING PAGE: *Kick in the Pants*, 1980, graphite on drafting film, 10 x 14 inches. National Museum of American Art, Smithsonian Institution, Washington, D.C.

New Act, 1981, graphite on drafting film, 14 x 10 inches. National Museum of American Art, Smithsonian Institution, Washington, D.C.

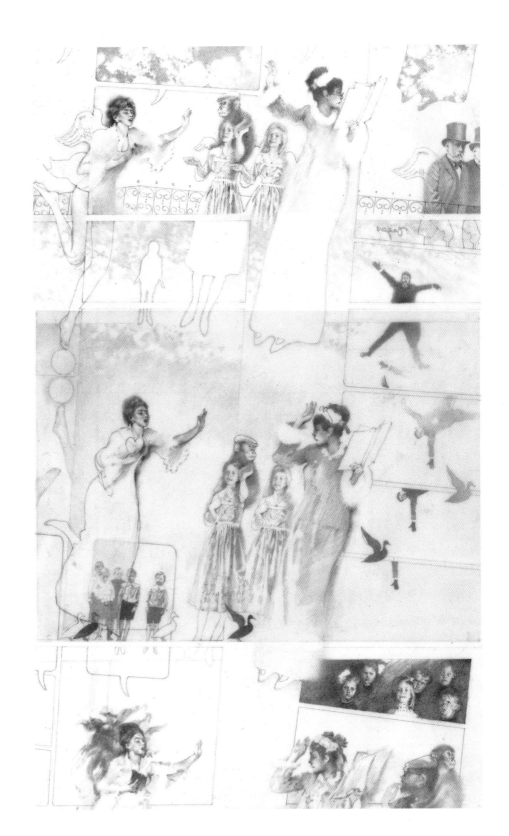

After Degas, 1982, graphite on drafting film,
14 x 8½ inches.

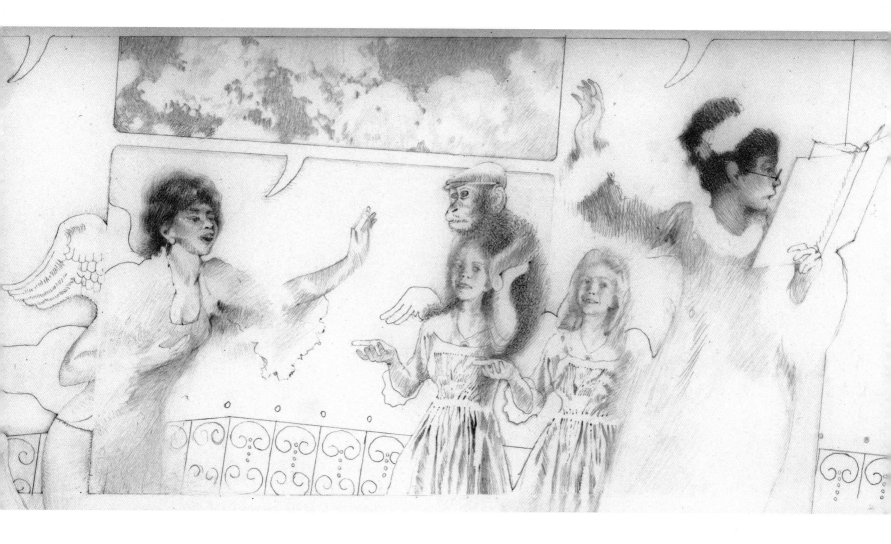

After Degas, detail.

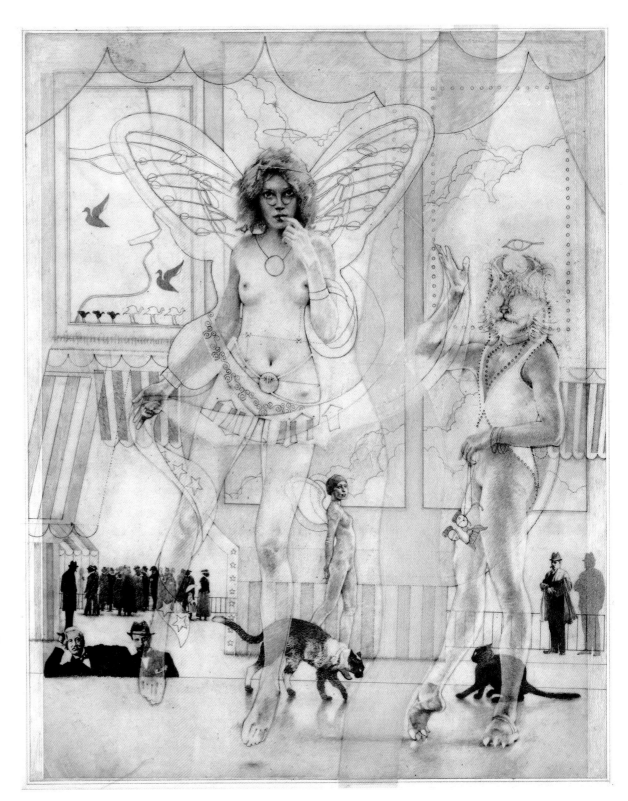

New Act (second version), 1982, graphite on drafting film with Cronaflex collage, 15 x 12 inches.

FACING PAGE: *New Act* (first version), detail.

70

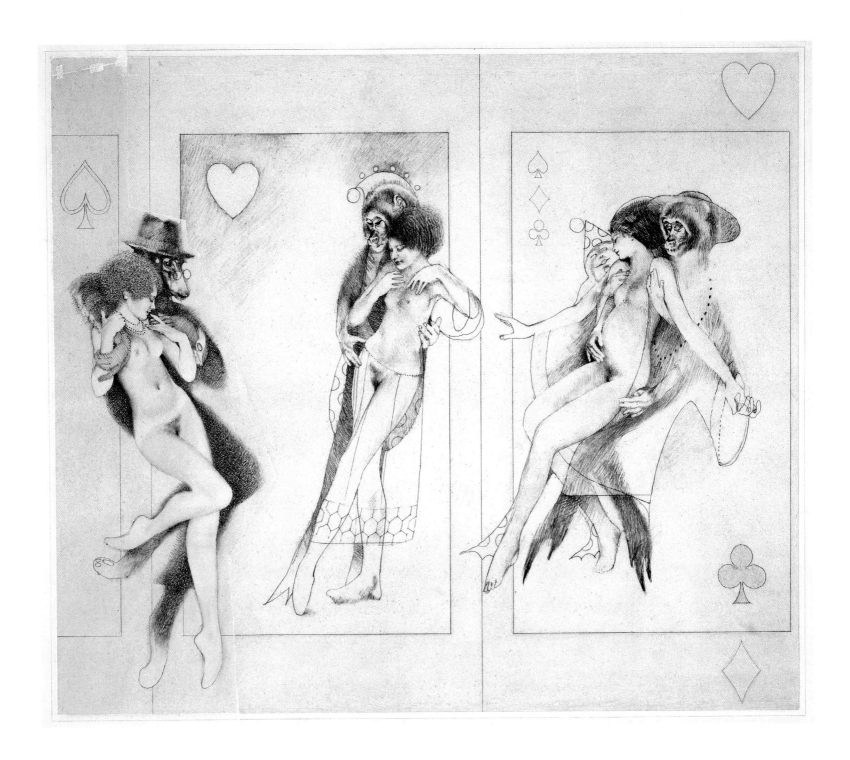

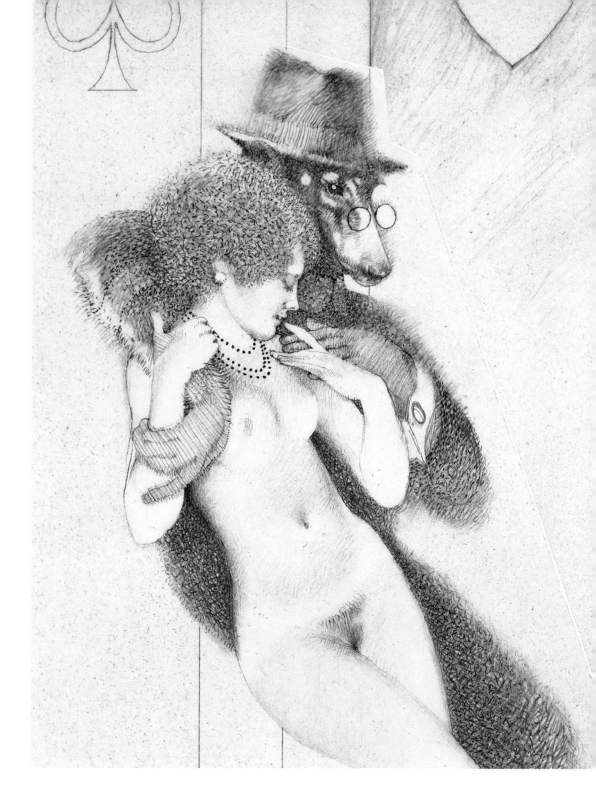

FACING PAGE: *Dancing Lesson* (second version), 1982, graphite on Cronaflex collage, 9 x 10 inches.

Dancing Lesson (second version), detail.

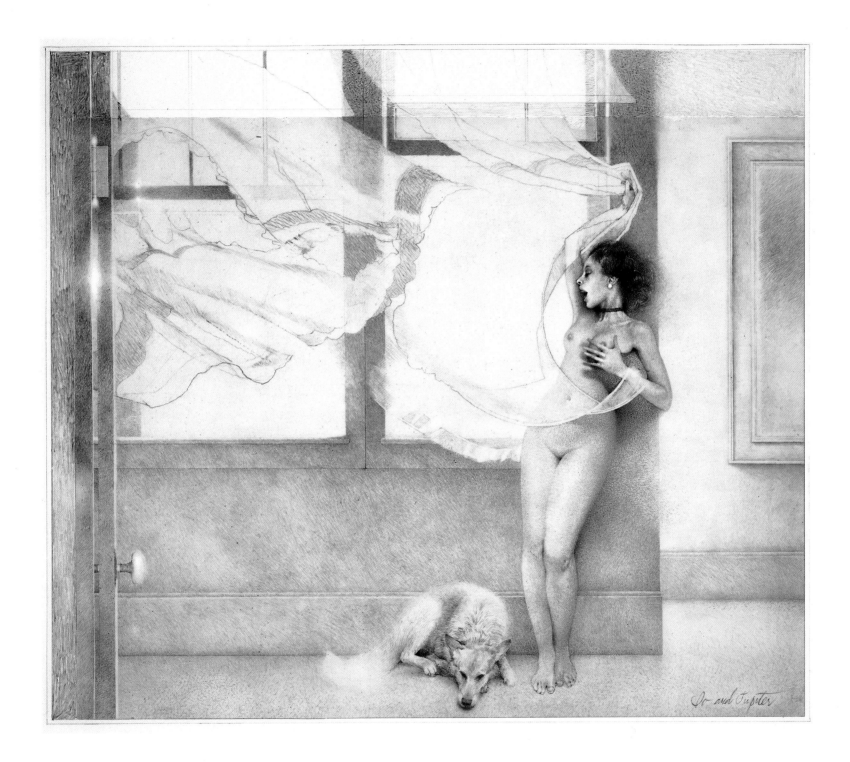

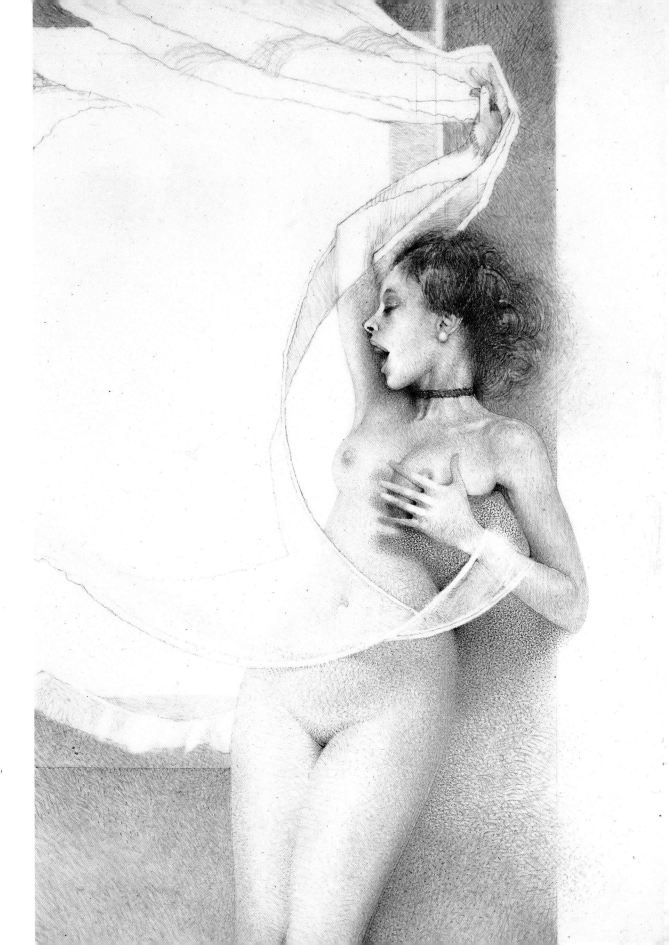

FACING PAGE: *Io and Jupiter*
(second version), 1982,
graphite and crayon on
Cronaflex, 9 x 10 inches.

Io and Jupiter (second version),
detail.

Klimtomania, 1982, graphite on drafting
film, 18 x 10 inches. National Museum of
American Art, Smithsonian Institution,
Washington, D.C.

Study for *Time with Celia*, 1985, graphite on drafting film, 16 x 12 inches.

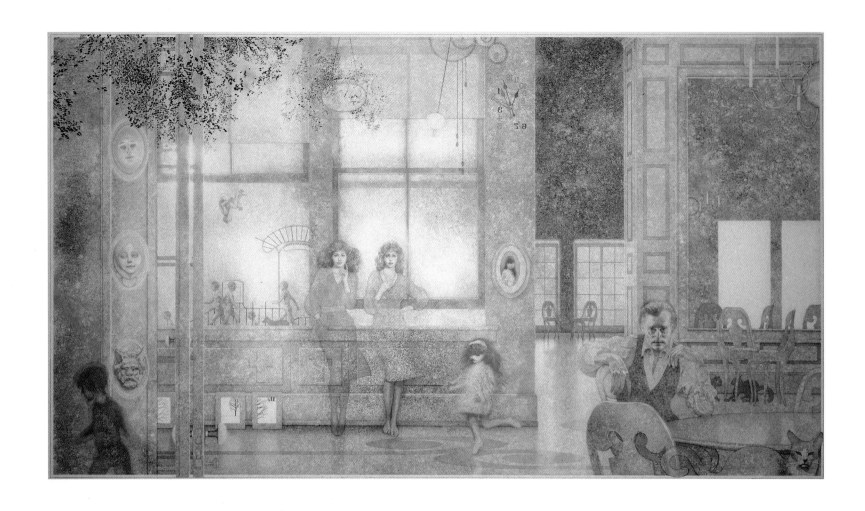

Interiors I: Family Reunion, 1984, ink on
Mylar, 20 x 36 inches.

FACING PAGE: *Interiors I: Family Reunion,*
detail.

78

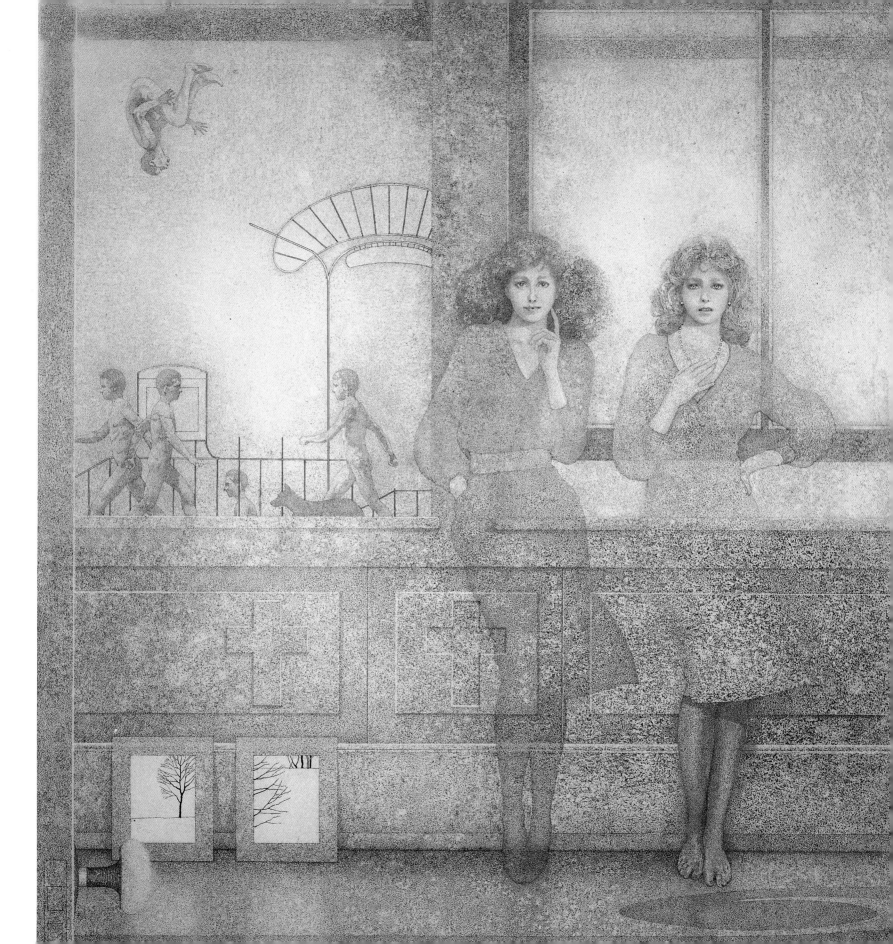

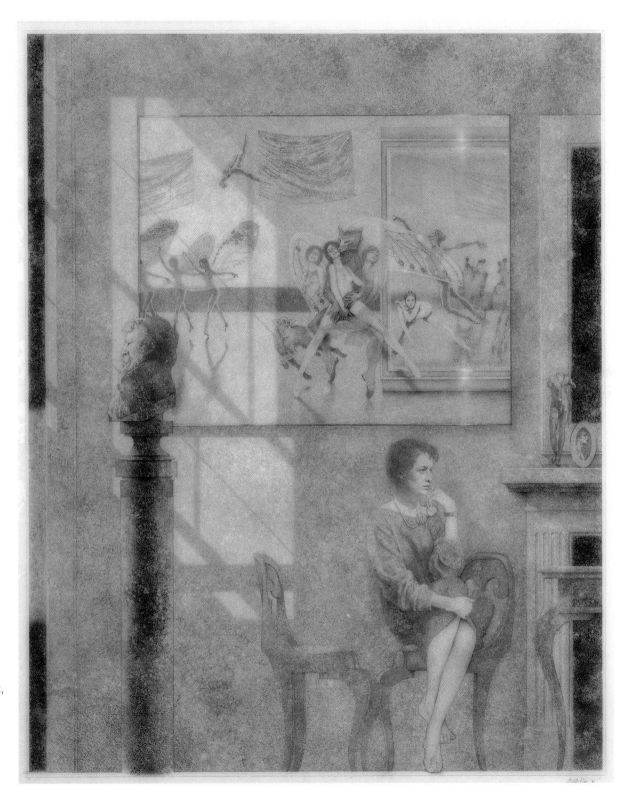

Interiors II: Stolen Moments,
1986, ink on Mylar,
30 x 24 inches. National
Museum of American Art,
Smithsonian Institution,
Washington, D.C.

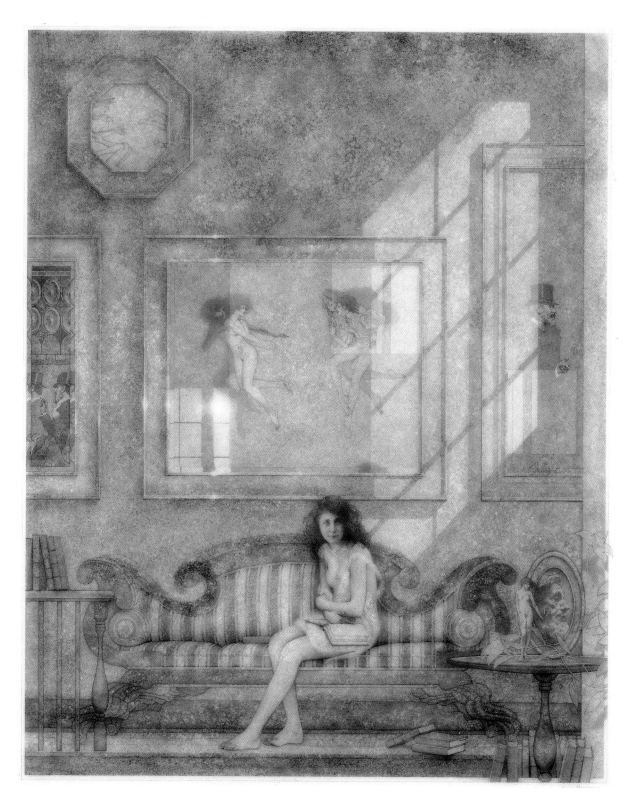

Interiors III: Time with Celia,
1986, ink on Mylar,
30 x 24 inches. National
Museum of American
Art, Smithsonian
Institution, Washington,
D.C.

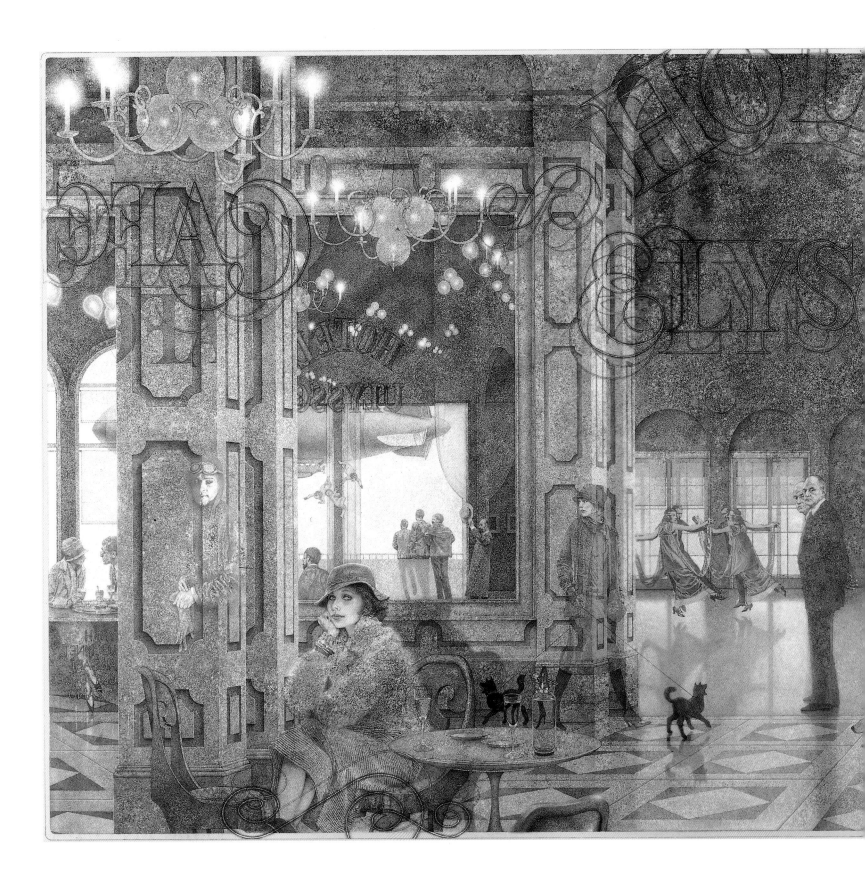

Interiors IV: Hotel Paradise Café, 1987, ink on Mylar, 24 x 36 inches.

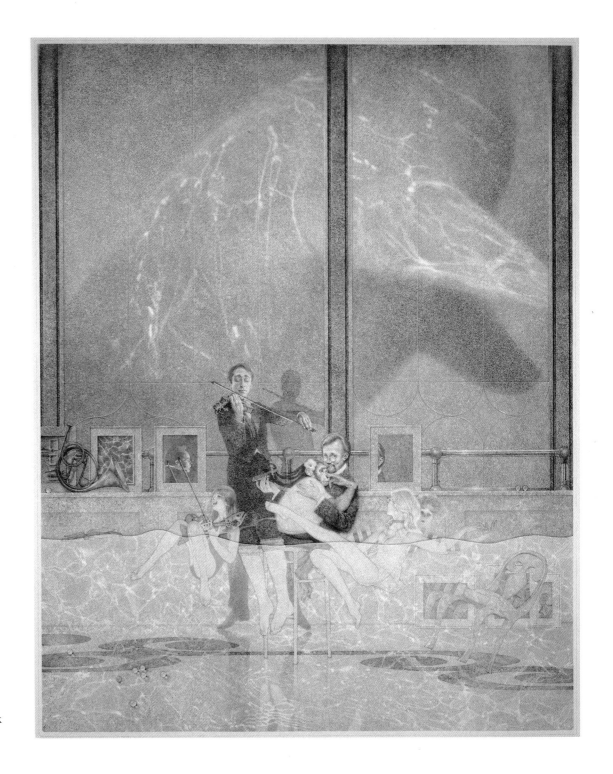

Interiors V: Water Music, 1988, ink on Mylar, 30 x 24 inches.

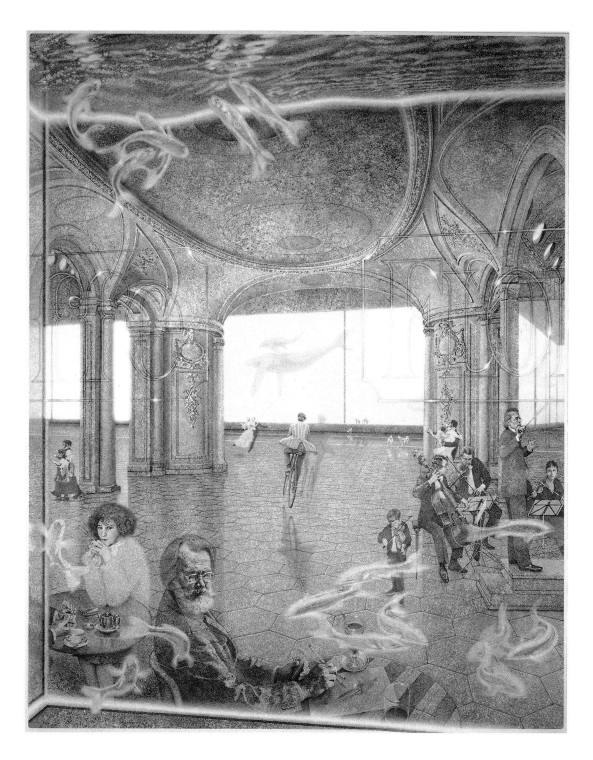

Interiors VI: Soundings, 1989, ink on Mylar, 30 x 24 inches.

II Some notes on *The Train from Munich*

I suppose *The Train from Munich* is a print for my wife, Edith, and her making it out of Germany in 1939.

The image started with a photograph by Eugène Atget of a girl looking out of a Parisian café window. Who was she? While I was in Bellagio I did a drawing of the piece, repeating elements of the window to suggest an entrance. I was thinking of James's *Aspern Papers*, which I was working on, but this drawing kept luring me back into the unfinished *Interiors* series. I knew I needed a seventh print to complete the series' symmetry.

When I started on the image again, I found that the scale of the girl in the window had to be reduced in order to suggest a greater scale to the architecture. But where was this café? The idea of the stairs going up at the right and going down in front came very quickly, as did the young woman coming up the stairs, a figure bor-

rowed from the tête-à-tête pair in *Hotel Paradise Café*, 1987, in turn borrowed from the 1925 André Kertész photograph of the Café du Dôme in Montparnasse. Originally I intended the print to be *her* story. I knew she should be coming from a train, and I knew that as she headed toward the farther steps she would never get past the entrance of the café, which I was already calling the Café Dante.

The train suggested a train station, which I rather freely improvised from photographs I had taken years earlier of the train station in Budapest. The choice of Budapest strangely foreshadowed a much more significant direction the image later took. With the train I wanted a repetition of windows echoing the repetition of the station's glass roof and walls, in turn echoing—in the insistence on geometry—the impersonality and relentlessness of the war machine building up in Europe.

Trains began to suggest deportation. And in that context, the steam—which I had introduced to relieve the relentlessness of the geometry—began to take on the weight of smoke and furnaces. The steam becomes even more like smoke and dust as it meanders through the café and toward the steps. I play it up to obscure the Café Dante sign, which had soon begun to seem to me pretentious and inflated. I keep the Hôtel Metropole sign as a more subtle reminder of an Underground.

The doorman is modeled on Marcel Duchamp. This is partly unfair revenge. I wanted an obsequious and appeasing man at the entrance, welcoming an unknown—and unseen—personage coming down the stairs. The revenge is for the escapades of Dada, the Mona Lisa moustaches, urinals-as-sculpture that heralded the Pop art of the sixties and the general trivializing of

Interiors VII: The Train from Munich, 1991, etching and engraving, 20 x 36 inches.

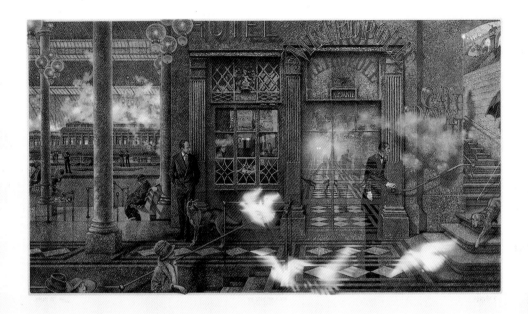

art that today is so ubiquitous. This figure is my moustache on Duchamp.

On a more serious plane, the elegant butler, the artist, and the intellectual are epitomes of European culture all about to be swept away by the juggernaut in the tunnel. Already Duchamp is becoming transparent.

Around the doorman are various Duchamp puns: the figures descending the staircase, the images transparent as if on glass. The figure of the doorman did not work for me for the longest time—it was not until I had added the smoke gathering

over his head and the white gloves that I could finally accept him.

I seriously considered more than a few people as participants in this image, some of whom were actually put in and then taken out: Jean Cocteau (twice); René Magritte; Magritte's back; many versions of Duchamp; Kertész's wife, Elizabeth; Kertész; Tristan Tzara; Hitler's dog Blondi; the collector Albert Bender; the photographer Hippolyte Bayard; Ernst Ludwig Kirchner; Robert Mapplethorpe's hand; and James Joyce. Cecil Beaton's Lady Diana Cooper did make it in (lower left

corner), as did Paul Klee (farthest sleeping man) and a Josef Koudelka gypsy above the sleeping dog. The sleeping man on the bench is from an image in Kertész's volume *On Reading* (1971). I put the man to sleep and gave him a bowler hat in honor of Magritte.

In the upper corner a tiny cityscape with a parade of banners holds echoes of Leni Riefenstahl. Three men have crossed over from *Hotel Paradise Café* and another three from my 1967 print *Julia Passing*. Albrecht Dürer's soldier from *Knight, Death, and the Devil* has turned into a statue, and

from the same source I have borrowed the dog that rushes down the steps and snaps at a flock of doves. The birds were added very late, to leaven the increasing density of the image. It was then that I made the dog vicious. He is on a leash. The unseen owner has an umbrella, an attribute of self-protection. I now give him a cane. He has become blind.

The man next to the window, who is also holding a leashed dog, is Raoul Wallenberg—the savior of thousands of Hungarian Jews who himself disappeared into Stalin's darkness. I didn't think of him at first and it now seems eerie how the setting was already derived from Budapest long before his likeness suggested itself. It was not until after the image was completed that I realized the connection and wondered to what I owe the poignant coincidence.

The figure derived from Wallenberg is the heart of the image. He has turned to see the commotion coming down the stairs, as has his dog. They can see what we cannot.

The dog in the terminal, however, is asleep. Three children peer intently at a group of people standing on a platform. No one pays any attention. They are all asleep.

In the window, my Atget girl, the original impulse for the image, has turned into Edith at the age of twelve; Edith still has photographs of herself in England at about that age, charming the photographer and us all. Between her and a standing man is a tiny portrait of the younger of our two children, Naomi, repeated from the 1984 *Family Reunion*. In that print I used a double exposure of Naomi as a stand-in for my younger sister, with whom I was very close in childhood and whose subsequent history has had more than its share of troubles. Do I intend the portrait, here, to suggest survival? At the right of the window, the figure from *Interiors I* still broods about things that, as of *Interiors I*, were still unclear. They are clearer now. This figure had my hairline, forehead, and glasses, but basically the face was taken from Arnold Newman's 1963 photograph of Alfried Krupp, the German munitions industrial-

ist. Did I really think, in 1984 when I was working on *Family Reunion*, that my choice was based solely on Newman's striking lighting effects? The *Interiors* series seems to have had an ultimate destination from the start.

At the right of Edith stands a man whose daughter did not escape. He is derived from Arnold Newman's eloquent portrait of Otto Frank.

For many of us the blackness that fell during the Third Reich has redefined the boundaries of humanity. It revealed a depth that, once seen, is always there and informs everything. *The Train from Munich* is specific and in some ways personal. But I intend its images of smoke, descending steps, disappearing figures, of sleep and blindness to have a much more general application. They not only evoke the historical past, which has by now assumed mythic dimensions, but point toward any time in which we allow darkness to prevail through our own free choice to be blind.

I see the train from Munich as the headlights in the tunnel. It seems poised in time, unmoving. But only for the moment.

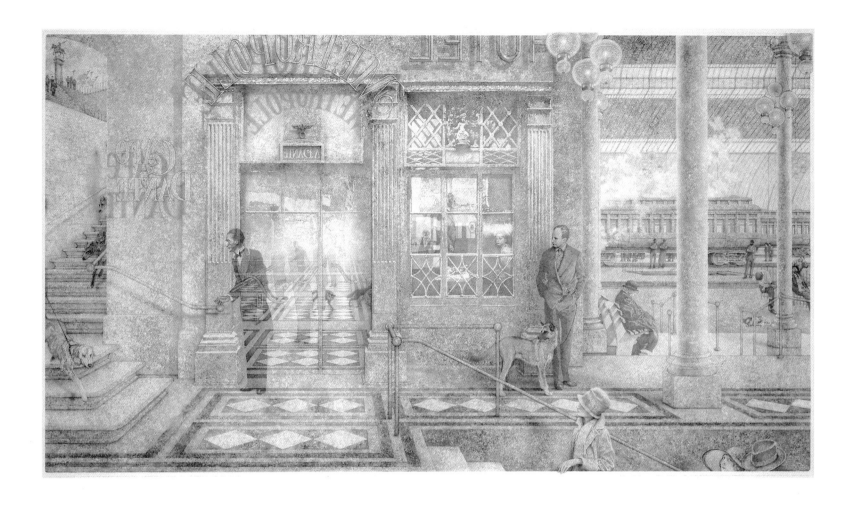

Interiors VII: The Train from Munich, 1991, ink
on Mylar, 20 x 36 inches.

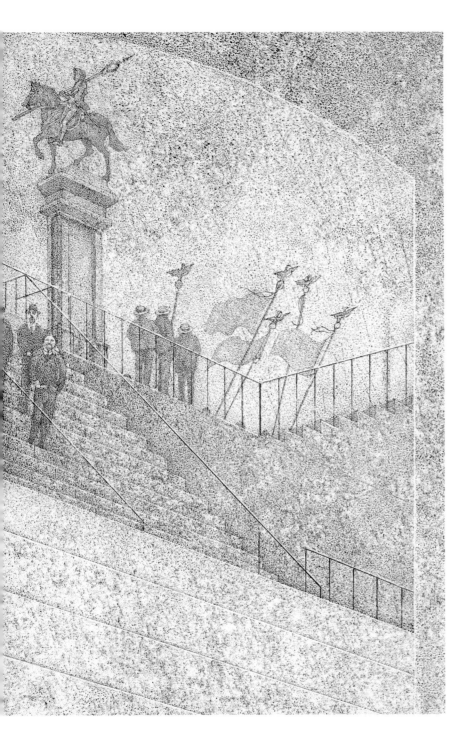

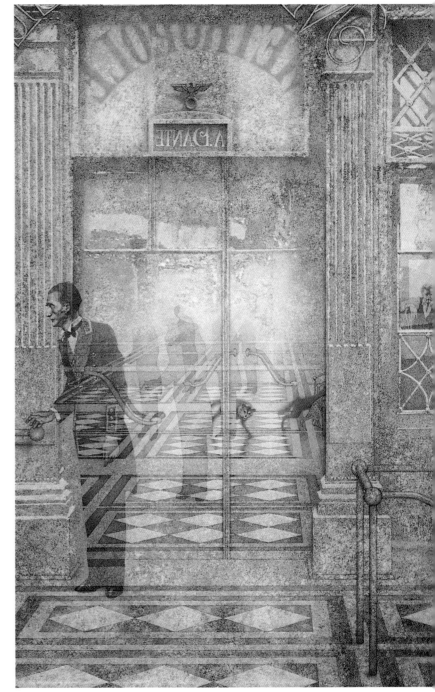

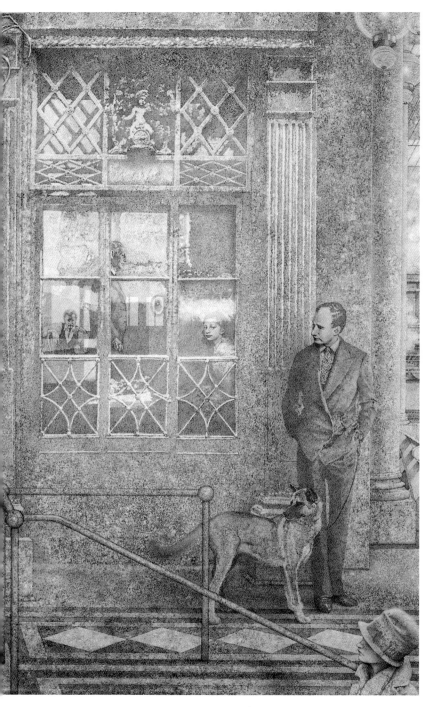

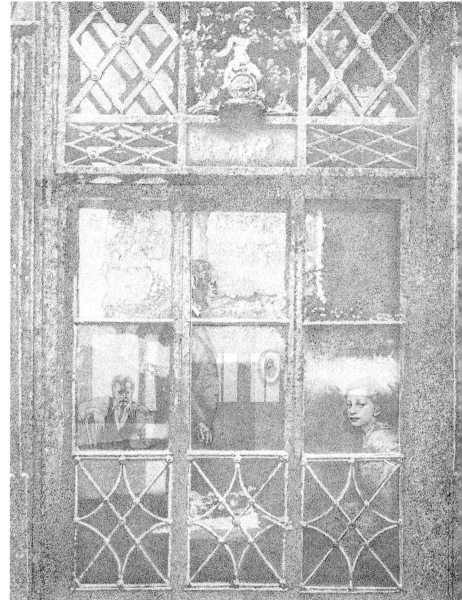

Interiors VII: The Train from Munich, details.

III *The Aspern Papers*

In 1990 I was given a residency at the Rockefeller Foundation Center in Bellagio, Italy, to begin a suite of images centered around Henry James's *Aspern Papers*. Ever since I had worked on *The Jolly Corner* in 1969–71, based on James's late story, I had wanted to complement his American mode by creating a series of images for one of his earlier European stories. I kept putting this off because I have such an intense discomfort with the idea of literal illustration.

When I did *The Jolly Corner* series, which was commissioned by the Aquarius Press, I was still at a point in my career where a commission was an important event for me. I was given total freedom to explore directions that were not really illustration in the traditional sense. I realized that in

order to circumvent the slowness of my work I would need to devise a method of producing many images from a minimum number of drawings. I worked this out through a theme-and-variations procedure that required a base of only seven drawings to produce twenty-one prints. I eschewed literalness and looked at the story from the viewpoint of its thematic elements on which I ran a kind of discursive series of variations.

With *The Aspern Papers* I felt that it would be a new challenge to break away from this three-for-one format and produce a unique drawing for each image. I knew that this would be so time-consuming that I would have to abandon the printmaking step altogether, and I decided that the suite would be entirely

one of drawings (though I have agreed to do a single print to be included in a deluxe edition).

I turned to paper with graphite as the medium for *The Aspern Papers* for several reasons. First, there is the material itself. Although drafting film is supremely permanent and reasonably sturdy if handled correctly, a great many people express discomfort with its unfamiliarity. Ink on Mylar, to the contrary, is relatively fragile—though Mylar, too, is so permanent that it is the material of choice in archival systems. In any case, both materials seem to present problems to the collector. I must confess that I have been perfectly happy to keep these drawings in my possession. I have a rather proprietary impulse when it comes to my unique pieces (as

opposed to my multiples) and feel a secret joy in keeping them to myself. The question was whether this was in my own best interest—either psychologically or professionally. And then, I was having a problem with classification: since most shows of drawings are referred to as "works on paper," my drafting-film pieces caused a certain perplexity and found themselves in limbo. It seemed time to face a medium I had not fully explored.

Another departure from *The Jolly Corner* approach, one that still avoids conventional illustration, was to skirt James's narrative and instead to take as my subject matter the same source material from which he derived his tale. These sources gave me, of course, James himself; his family, particularly his brother, William; James's beloved Venice; the Palazzo Cappello and its gardens, which inspired the palazzo of the narrative; Shelley/Byron and Claire Clairmont; and the close friend Constance Fenimore Woolson, who, the James scholar Leon Edel believes, is almost certainly James's basis for the younger Miss Bordereau, Tita.

The suite has a prologue and two main sections. The two prologue drawings, called *Jeffrey and Juliana*, evoke the Villa Diodati of the famous summer Shelley and Byron spent together with Mary Shelley and Claire Clairmont. In *The Aspern Papers*

Claire becomes the ancient Miss Bordereau, while Shelley and Byron, of course, provide an approximate and composite inspiration for Jeffrey Aspern.

I call the first full section *Recent Sightings: Henry in Venice*. This group of drawings puts James in a variety of roles—observer, passer-by, relative, central figure—and into various of my favorite Venetian piazzas and campi. Part of the magic of Venice, of course, is that it remains virtually unchanged; our Venice is James's Venice, as his Venice was the Venice of Byron and Shelley. Besides, James's description in *Italian Hours* of Venice as a sequence of stage sets makes it entirely natural to include him among the members of the cast.

In the first drawing of this group, James appears five times in different stages of his life. He stands in the campo of the Verrocchio *Condottiere* in front of the Scuola San Marco, notable for its amazing facade of trompe l'oeil paintings. The Scuola San Marco is now a hospital and seems an appropriate setting for someone from a family famous for both education and hypochondria. In the Campo Vio drawing (*Henry in Venice #2*), James, from a balcony, surveys that oddly Venetian movement of people in the act of passage; behind him, a corner of the Palazzo Barbaro is visible. It was in the Palazzo

Barbaro, where James had often visited, that he worked on the final draft of *The Aspern Papers*. He had first heard the tale of Claire Clairmont and the cache of Shelley and Byron letters at the rented palazzo of Vernon Lee, a close childhood friend of John Singer Sargent. The story was that a sea captain, Silsbee, insinuated himself into the Clairmont household and after Claire's death attempted to wrest the papers from her grandniece, who allowed that he could have them if he married her. Silsbee fled in terror and, according to James's informant, "was still running."

Sargent, a fellow expatriate much admired by James, frequented both the Palazzo Barbaro and more occasionally the Palazzo Cappello with the rest of the large circle that also included Vernon Lee and James himself. In *Henry in Venice #5* Sargent is in a boat, painting the Scuola San Rocco, which contains a Tintoretto favored by James. Sargent painted both a watercolor and an oil from what must have been that exact spot. In the last drawing of the *Henry in Venice* section (#8), James has joined the American painter in the garden of the Palazzo Cappello. Sargent, in mountain attire, magisterially and of course brilliantly paints some unseen ladies in a bower.

The final section of drawings is a series of interiors derived from an eerie day I

spent at the Palazzo Cappello. It includes a few key narrative elements and also points to the most poignant of James's personal connections to the narrative, his friendship with Constance Fenimore Woolson. I call the section *Cat and Mouse* after the furtive goings-on between the narrator and the Misses Bordereau. It seems equally appropriate for James's prose style and its intentional ambiguities, as he plays with the reader.

My efforts to find the Palazzo Cappello was an adventure in itself. The initial reference came from James's correspondence with the photographer Alvin Langdon Coburn in which James refers to the palazzo affectionately and less formally as Ca' Cappello, the Cappello Casa. (The last drawing, being more of a coda, does not strictly refer to the Ca' Cappello, as the narrator, back in his own study and much later, rues the sorry events of his disastrous adventure.) Locating the palazzo once it had a name proved more difficult. After many inquiries, I was led to Rosella Zorzi, of the Università di Venezia, who most wonderfully took up the sleuthing for me. An expert on Anglophones in Venice, she too wanted to see the place and was able, finally, to locate a key to the deserted building on the Rio Marin.

On a lovely, secluded canal near the railroad station, the palazzo looms over the *riva*, a gigantic, cat-infested devastation of a place. Inside, a ceiling has fallen in, leaving piles of debris. There are broken shutters, shattered windows, and doors off their hinges throughout. A strange aura of menace and secrecy hangs in the air, due no doubt to the fact that, as I was told, the building's last use was as a headquarters for fascist police during World War II. An enclosed garden at the side and an enormous garden at the rear containing much deteriorating baroque sculpture are grotesquely overgrown. What James had described as "quiet discouragement" and "gloomy grandeur" has become hopeless dereliction. Yet the grandeur is still there. The first- and second-floor *salas* are as magnificent as ever, and the grand architectural porticoes of the main staircases are splendid. I spent a haunted day photographing the majestic desolation.

That the building is in a near-final state of decay seems to comment on the eerie aptness of James's choosing it to represent *his* sense of a passing time in *The Aspern Papers*. As James's narrative comments on a period when the life of grace and civility was declining, so today we witness its final collapse.

If the gloom and grandeur of the palazzo set the mood for this last section, James's narrative gave me its cast. I found my Tita in Thomas Eakins's 1897 photographs of Jennie Dean Kershaw, a Philadelphia artist who many years after Eakins's death married his student and close friend, the American sculptor Samuel Murray. Kershaw's age is indeterminate in the photographs and seems to change from one to the next, as does Tita's age in the mind of James's narrator, who, in one scene, has her as dingy and elderly, while in another she is younger and "angelic," possessing "a phantasmagoric brightness." Indeed, Tita is a paradox: the narrator describes her as mild but not fresh, simple but not young, eyes large but not bright, hair plentiful but not dressed, hands fine but not clean. Kershaw, with the exception of the unkind reference to hands, displays a similar changeability in Eakins's photographs of her.

My models for Jeffrey Aspern were self-portraits of Robert Adamson and David Octavius Hill, the early-nineteenth-century photography pioneers. Needing photographs for reference, I wanted to get as close as possible to the period of Byron and Shelley. Hill has a Byronic flair, indeed. For their companions in *Ca' Cappello #5*, I appropriated and modified two of the figures from Sargent's three Misses Vickers. For the oval portrait of Aspern (#6 and #7) I found I needed to

shift my Byron/Shelley amalgam from Adamson and Hill to an 1855 self-portrait by the French photographer Paul Gaillard, which brought a certain appropriately melancholy air of loss to the "delightful eyes" and "friendly mockery" that the narrator finds in the oval Aspern portrait.

For the final image of the once-beautiful Juliana Bordereau I borrowed a photograph of Georgia O'Keeffe in her old age. I altered the occlusion and modified the eyes to echo James's repeated reference to the hidden, large, and once-beautiful eyes of the old woman. For the narrator, I used James himself, as he was in his forties when he wrote *The Aspern Papers*. But in the end (*Ca' Cappello* #7 and #8) I returned him to the splendid, sexagenarian appearance of HJ, the master.

An aspect of *The Aspern Papers* that fascinates me is the connection between James's portrait of Tita and his close friend Constance Fenimore Woolson. Fenimore,

as James called her, has been described as a rather spinsterly writer. James spent a great deal of time with her, but did not return her probably more than casual feelings for him. Six years after publication of *The Aspern Papers*, Fenimore committed suicide by throwing herself out of a window in Venice. James was appalled and stunned, no doubt partly blaming himself. He could not even bring himself to attend the funeral. Shortly after, returning to Venice and her apartment, he destroyed all his correspondence with her. One cannot help but notice the irony: in *The Aspern Papers* James clearly identifies with his male narrator's retreat in total disarray from a marriage proposal. Now, six years later, he is acting out the defining moment of his heroine—who burns the entire cache of Aspern's papers "one by one."

In their superb book *The Venetian Hours of Henry James, Whistler, and Sargent* (1991), Hugh Honour and John Fleming relate the

extraordinary account, from the recollections of an acquaintance of James, of James's attempt to dispose of Fenimore's black dresses in the lagoon. He beats them down, but they refuse to go under, billowing up around him like so many black balloons.

I had originally intended twelve to fifteen drawings, but the group did not seem to have a finish. There needed to be a point where the elaborations could begin to subside and in the end recede into silence. *Ca' Cappello* #6 and #7 were done quite rapidly, on one sheet of paper. In #8 I arrived at what I was looking for. I will let the image speak for itself and point only to the "chagrin" and "intolerable loss" that James evokes in the last sentence of his story. This last image comes full circle back to the first: the motif of rippling water has turned into shadows from Venetian blinds playing over the solitary figure. A picture of a boat is on the wall.

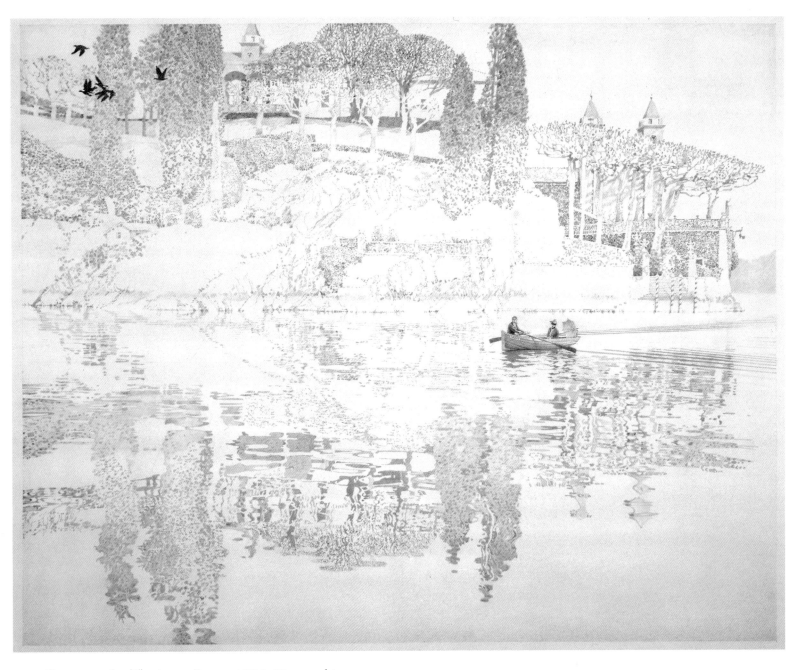

Drawings for *The Aspern Papers*, 1990–92, graphite on paper.

I PROLOGUE

Jeffrey and Juliana #1, 19 x 24 inches.

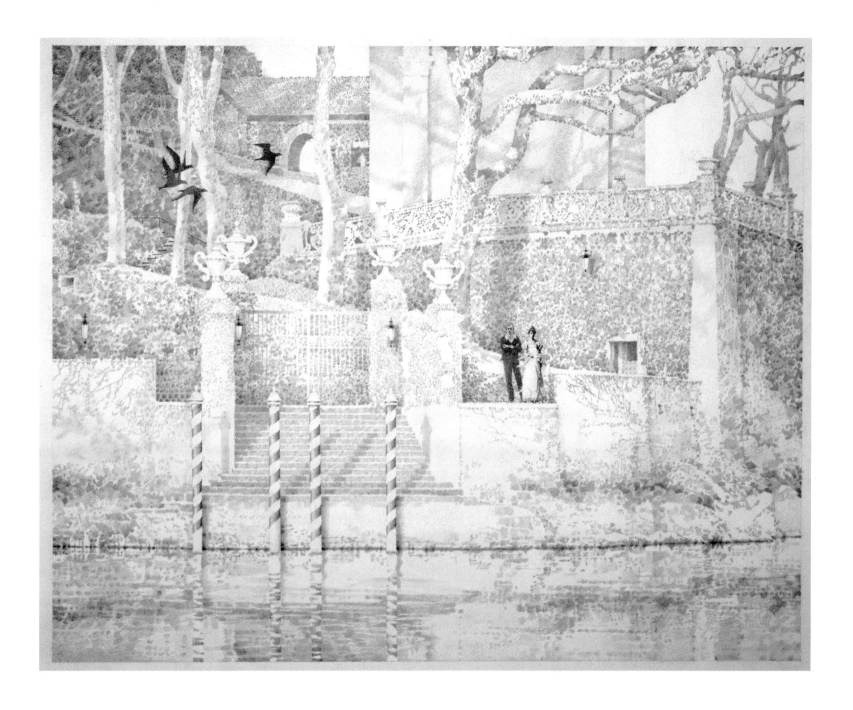

Jeffrey and Juliana #2, 19 x 24 inches.

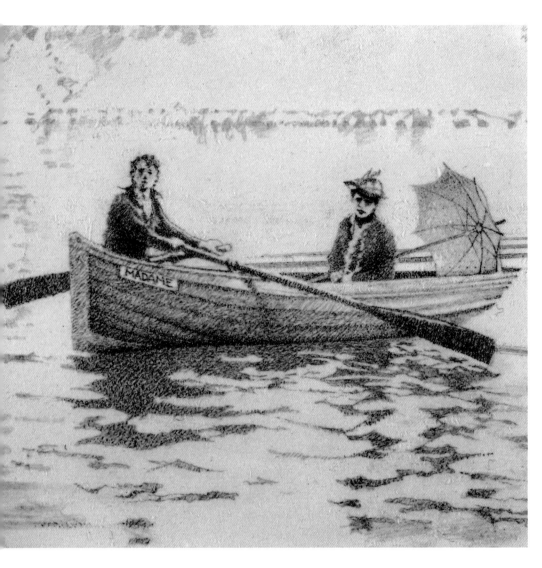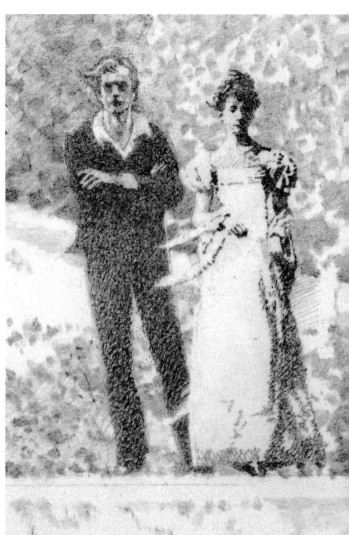

Jeffrey and Juliana #1, detail.

Jeffrey and Juliana #2, detail.

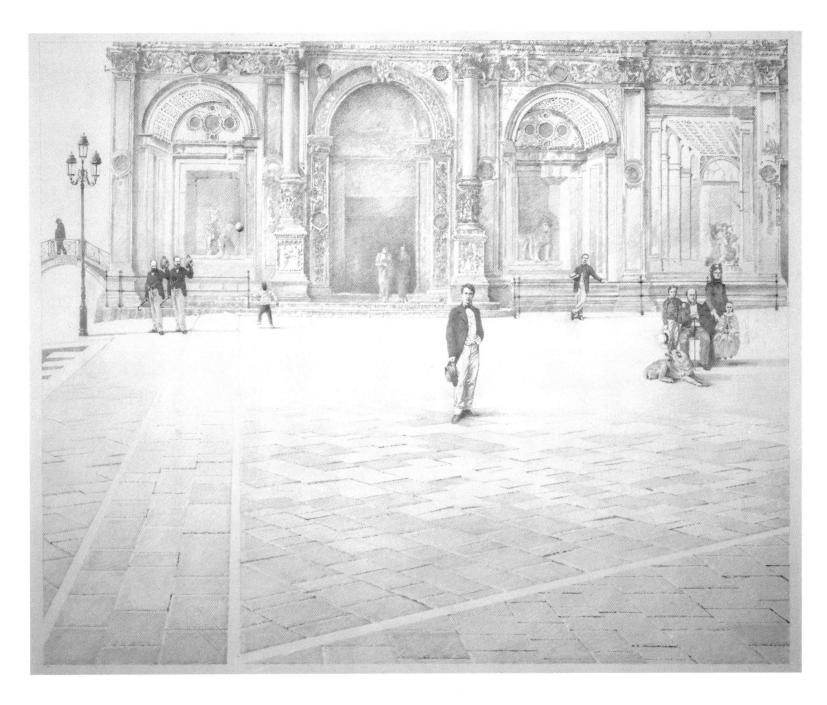

II RECENT SIGHTINGS
Henry in Venice #1, 20 x 25 inches.

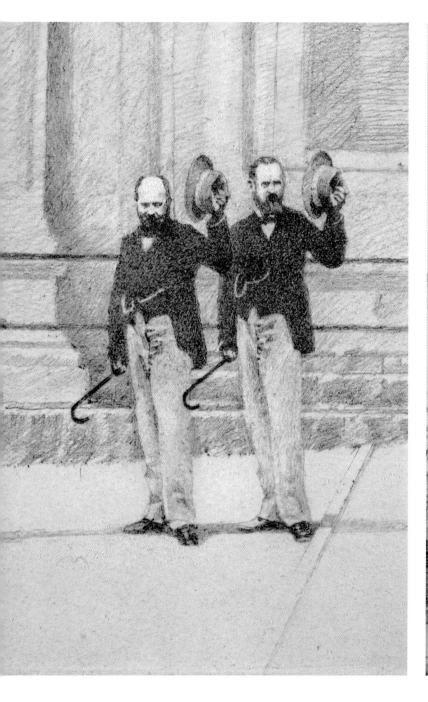

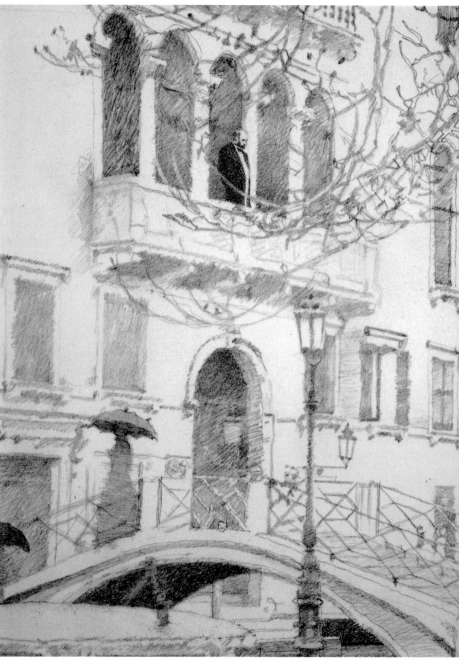

Henry in Venice #1, detail.

Henry in Venice #2, detail.

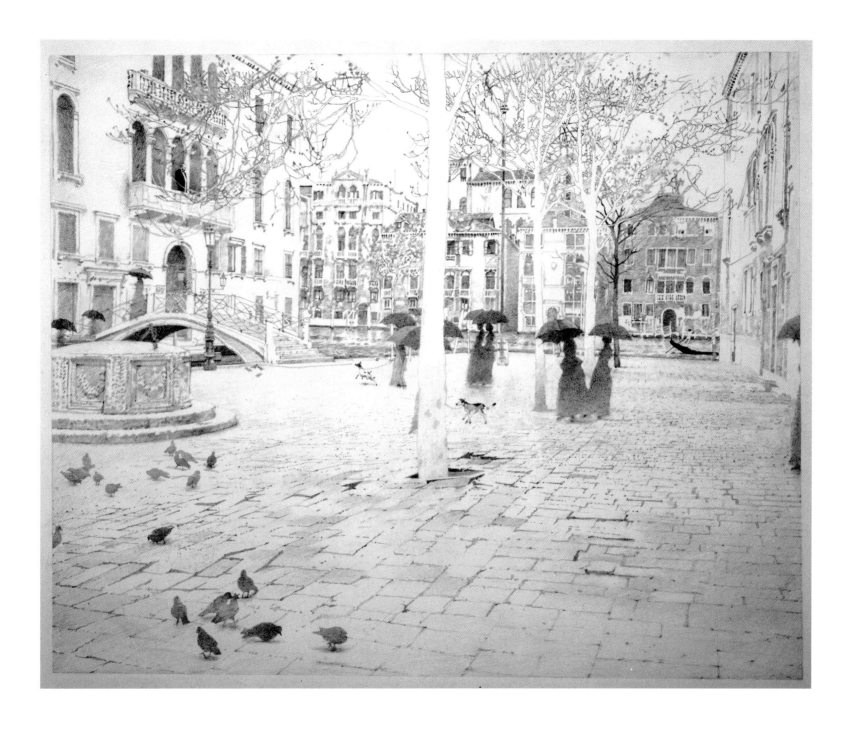

Henry in Venice #2, 19 x 24 inches.

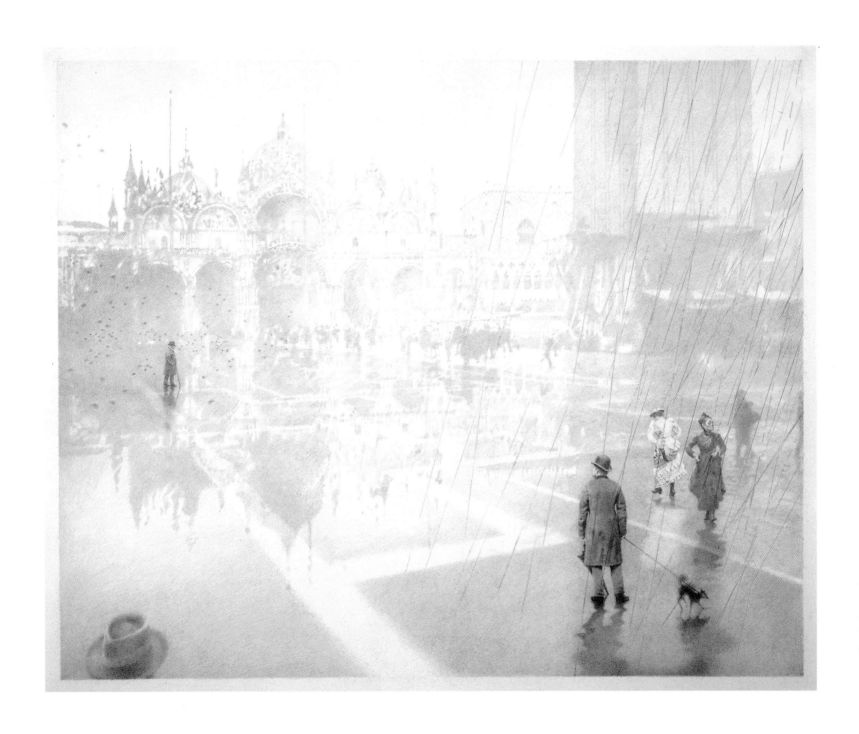

Henry in Venice #3, 19 x 24 inches.

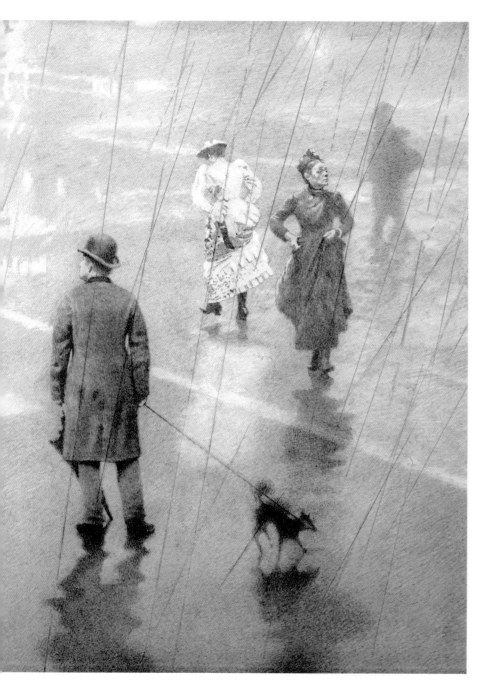 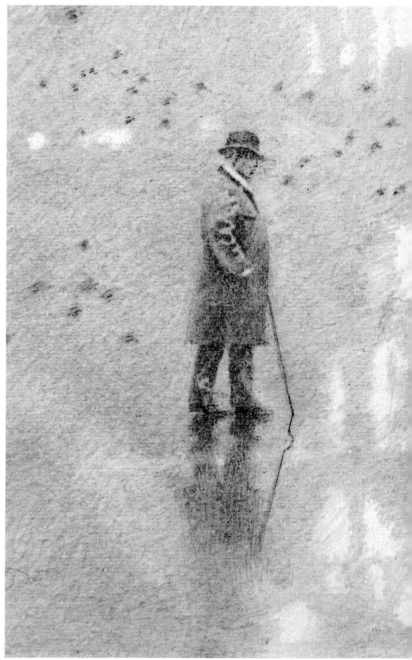

Henry in Venice #3, details.

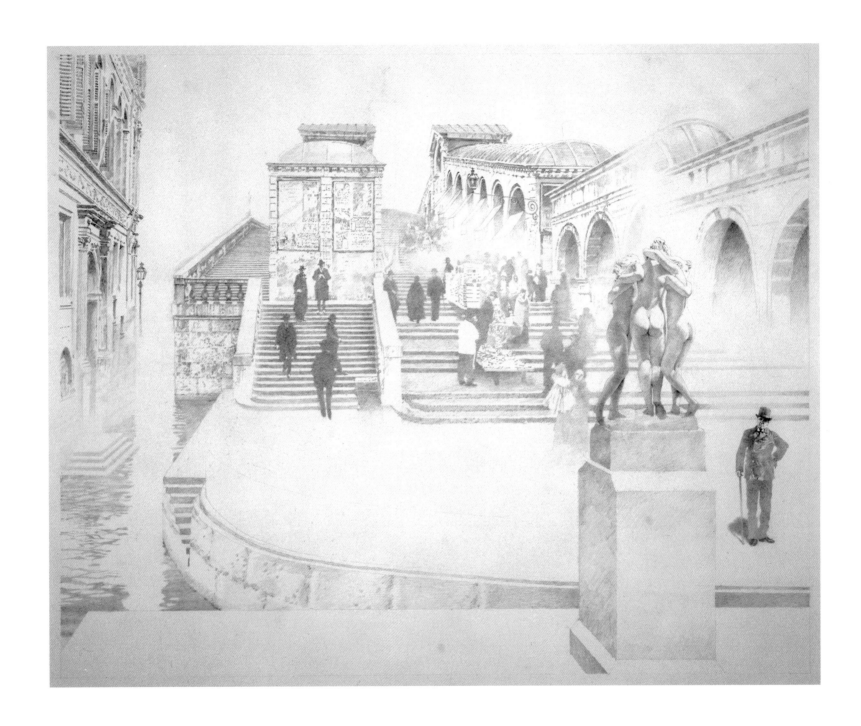

Henry in Venice #4, 19 x 24 inches.

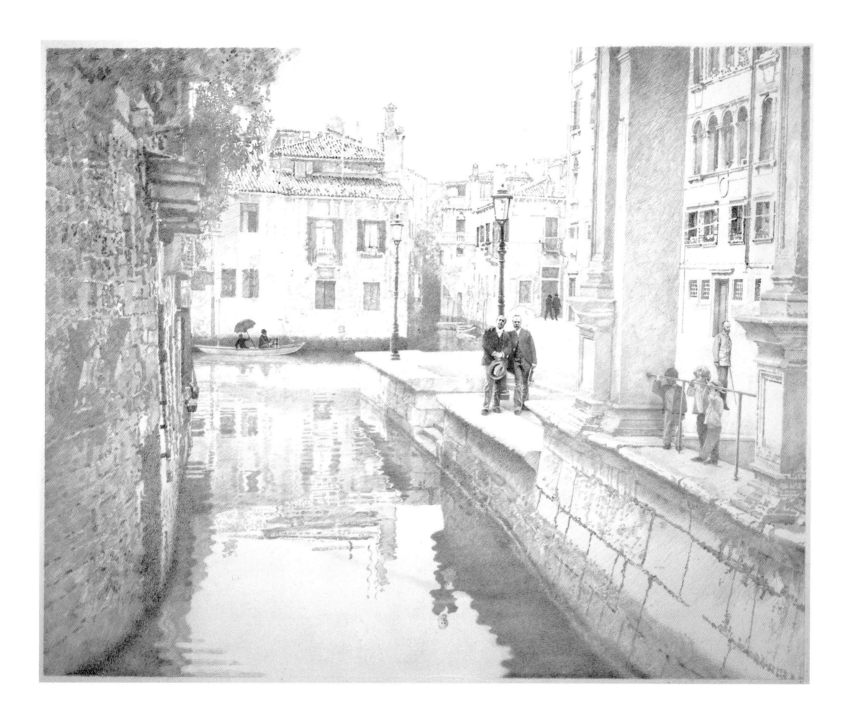

Henry in Venice #5, 21 x 26 inches.

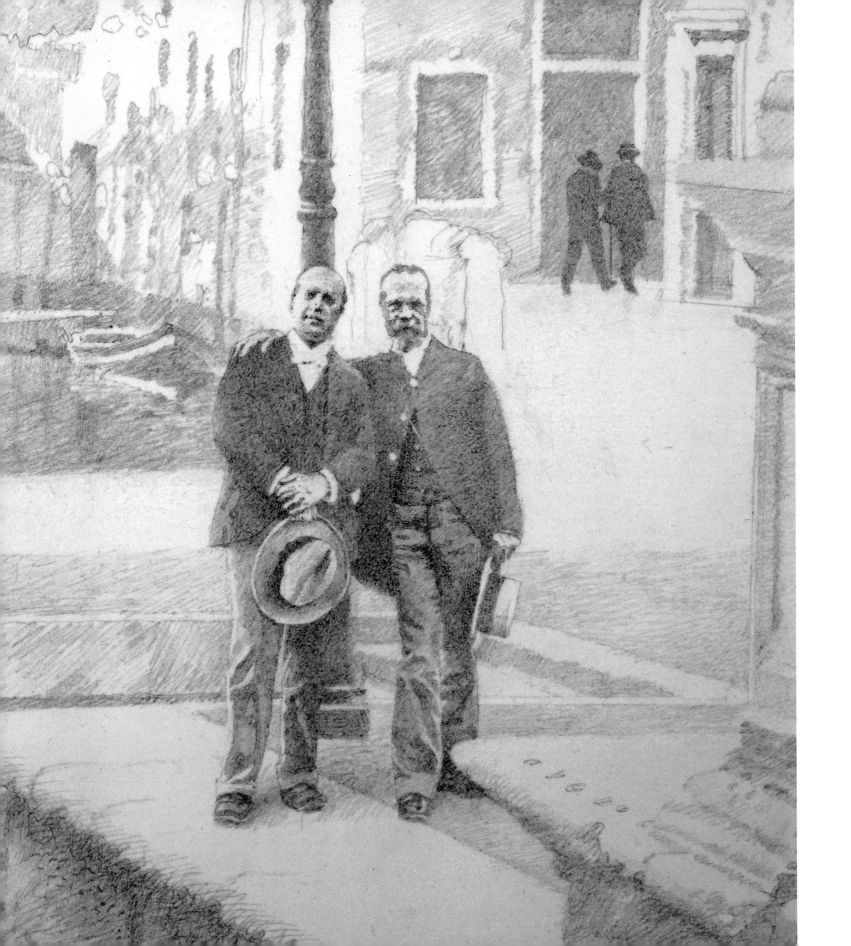

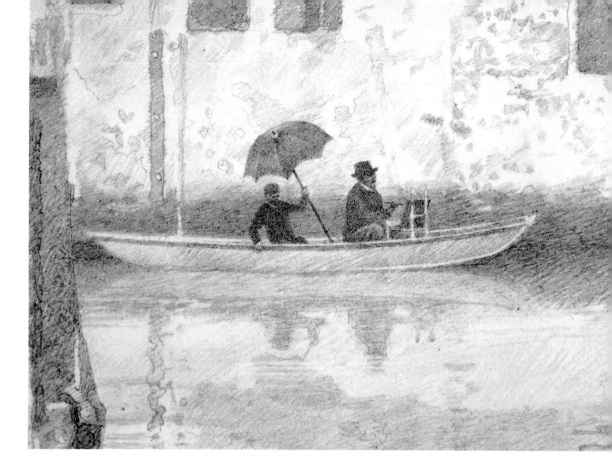

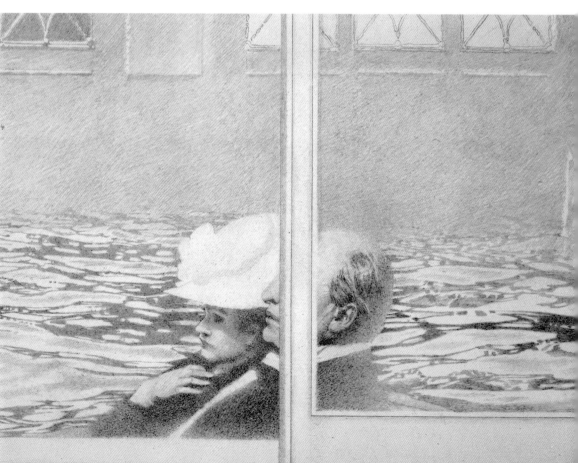

FACING PAGE: *Henry in Venice #5*, detail.

TOP: *Henry in Venice #7*, detail.

BOTTOM: *Henry in Venice #5*, detail.

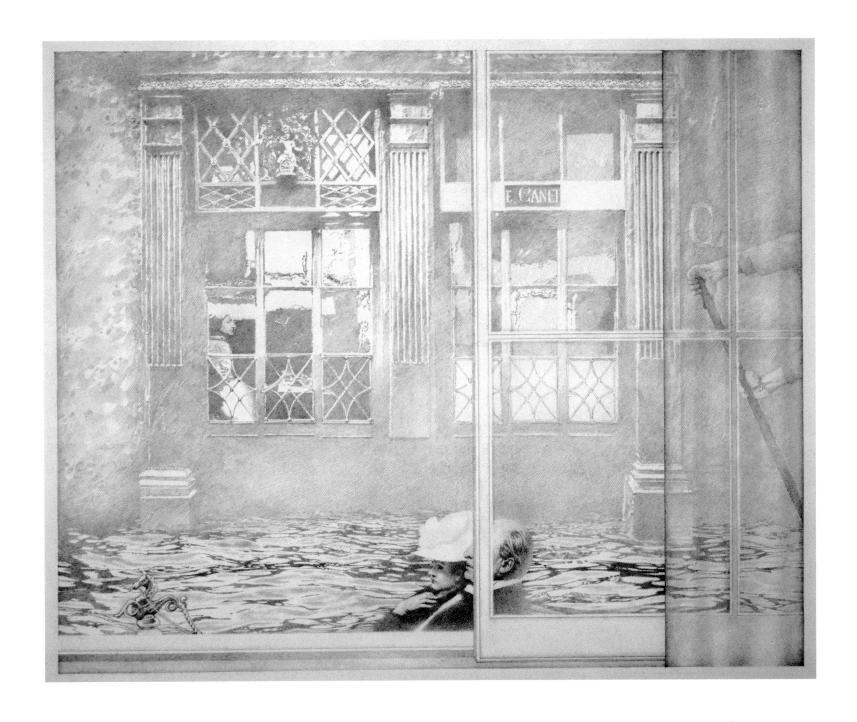

Henry in Venice #7, 19 x 24 inches.

108

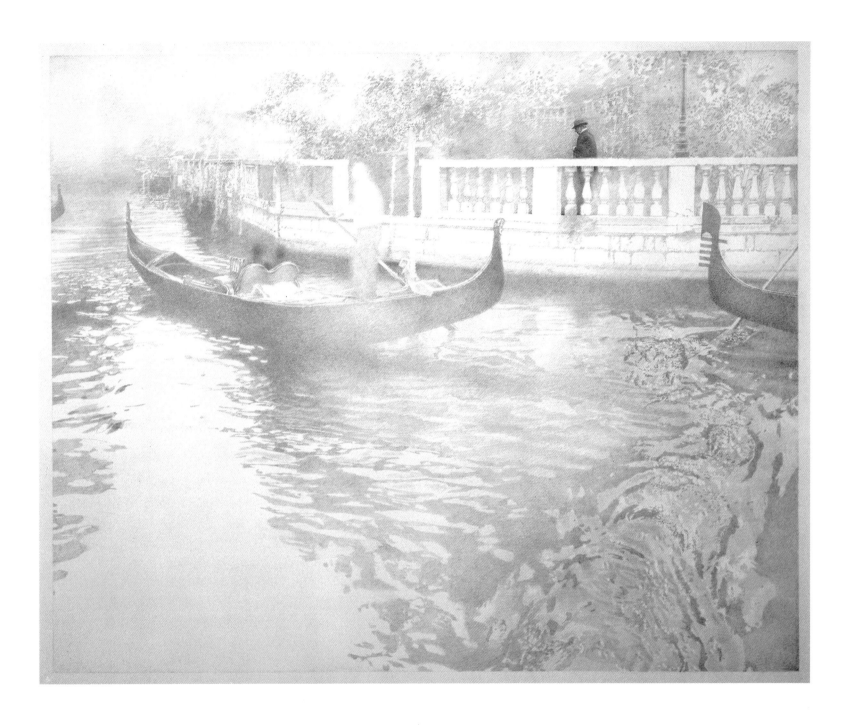

Henry in Venice #6, 19 x 24 inches.

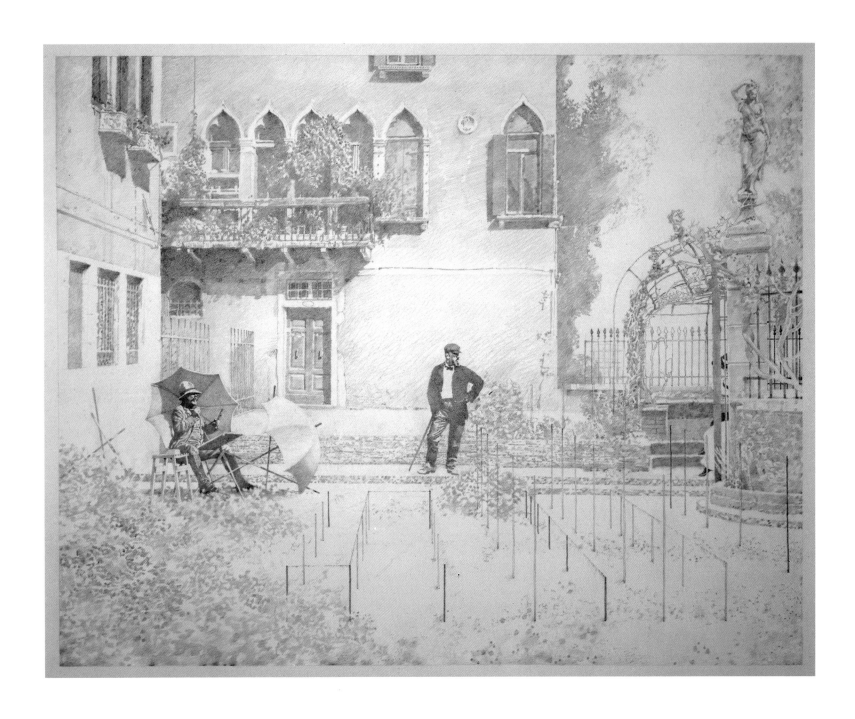

Henry in Venice #8, 19 x 24 inches.

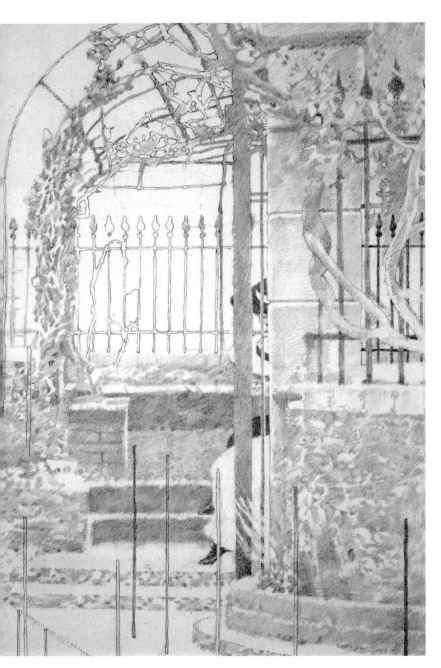

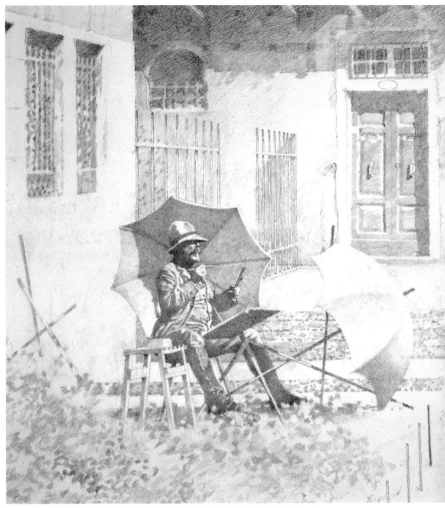

Henry in Venice #8, details.

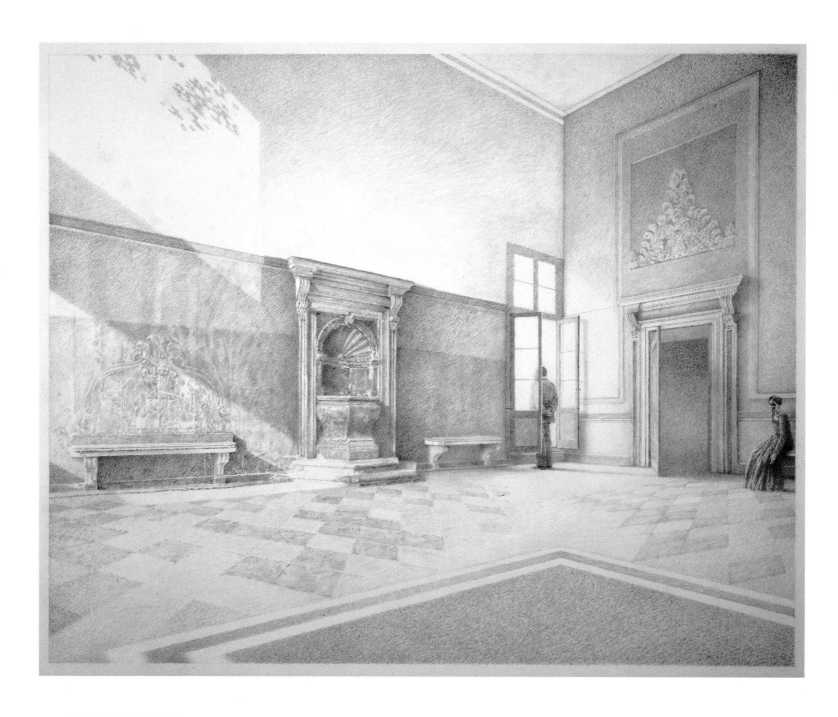

III CAT AND MOUSE
Ca' Cappello #1, 19 x 24 inches.

112

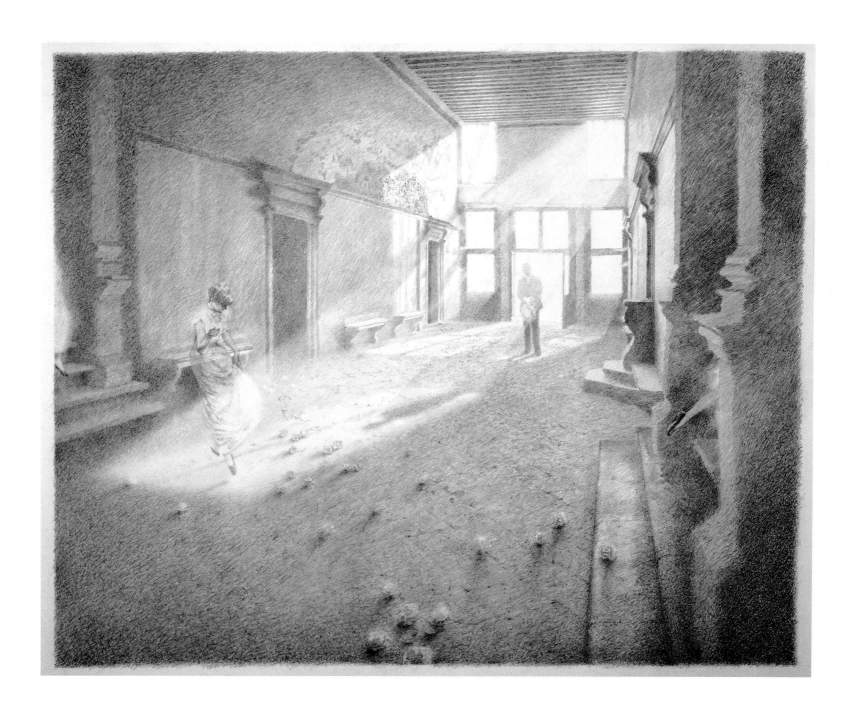

Ca' Cappello #2, 19 x 24 inches.

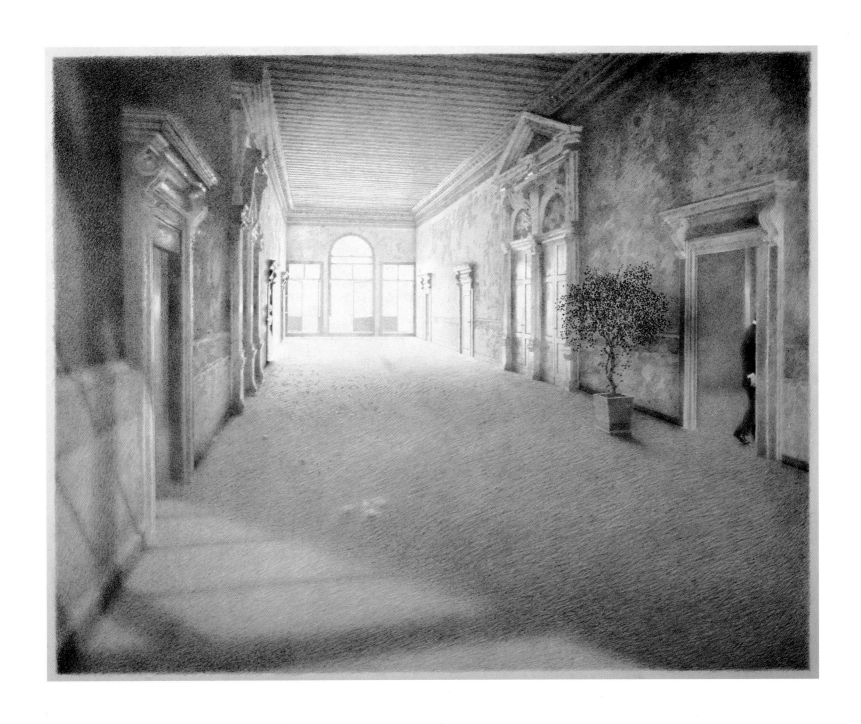

Ca' Cappello #3, 19 x 24 inches.

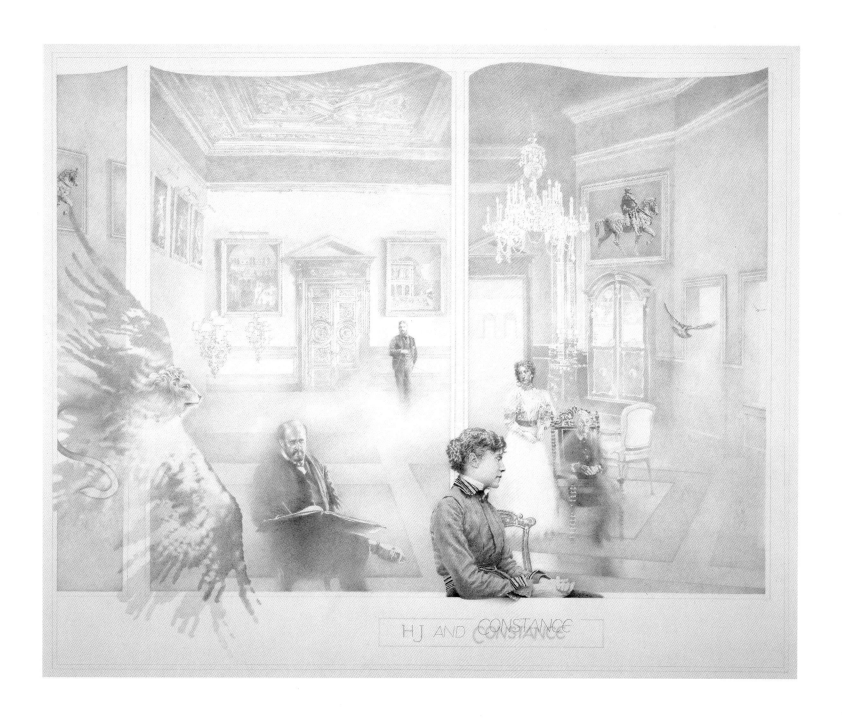

Ca' Cappello #4, 21¾ x 27 inches.

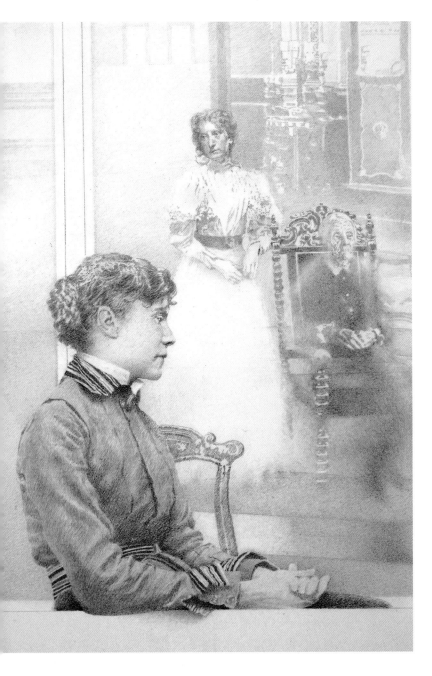

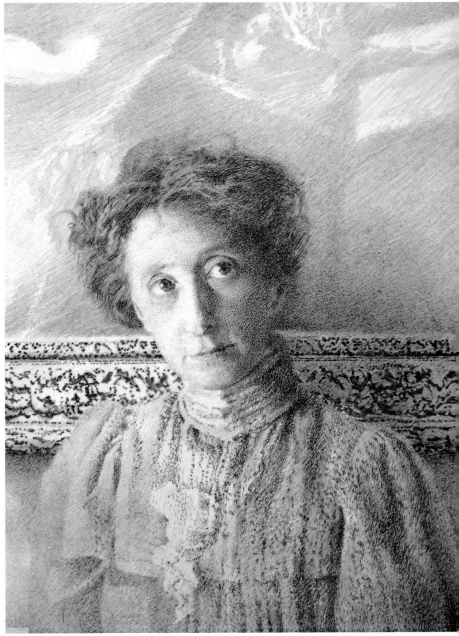

Ca' Cappello #4, detail.

Ca' Cappello #5, detail.

116

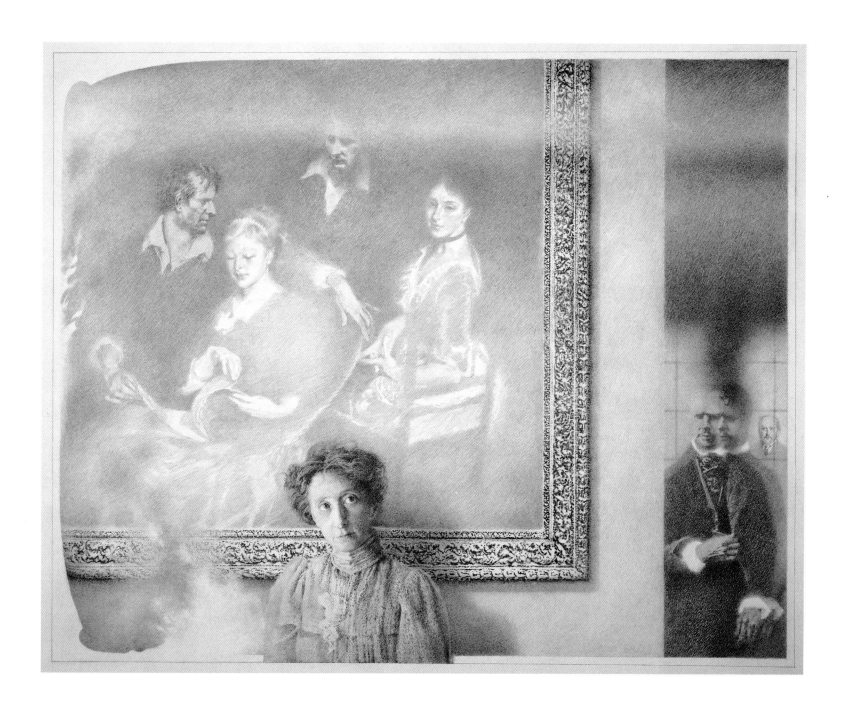

Ca' Cappello #5, 20 x 25 inches.

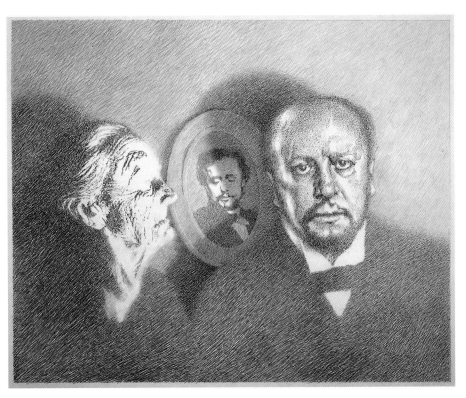

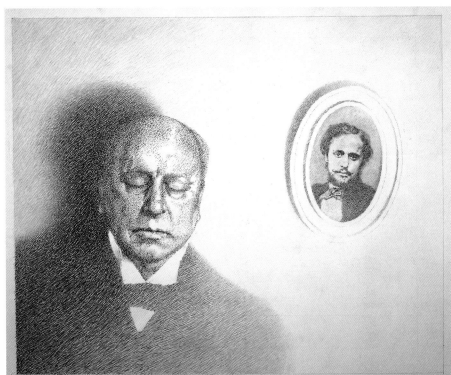

TOP: *Ca' Cappello* #6, 13 x 16 inches.

RIGHT: *Ca' Cappello* #7, 13 x 16 inches.

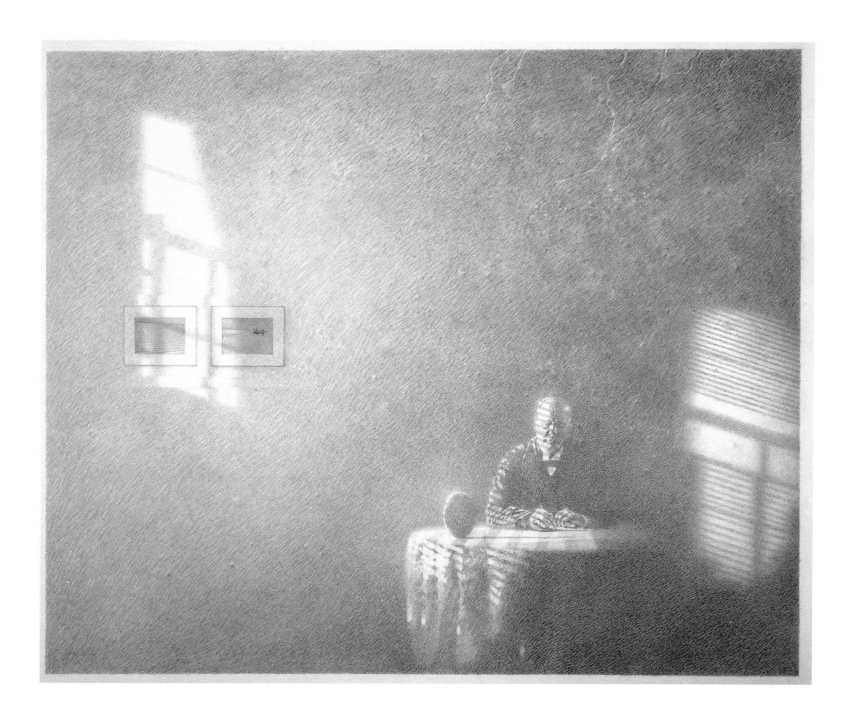

Ca' Cappello #8, 20 x 25 inches.

IV Inward and onward

The last two drawings bring us up to the present. *Garden with Henry*, 1992, is the ink-on-Mylar study for the original etching/engraving to accompany the deluxe edition of the *Aspern Papers* portfolio.

The final drawing, *Mary's Turn*, 1993, also ink on Mylar, is intended as a study for the first of two prints involving Mary Cassatt and Edgar Degas. The two artists had formed a close relationship for a decade, which eventually ran aground on the shoals of Degas's vituperative personality. And certainly Cassatt's goodwill from the start must have been tested by Degas's unrepentant chauvinism toward women.

In *Mary's Turn* Cassatt and Degas are playing billiards. It is now Mary's turn and she is about to run the table, to the intense annoyance of Degas, who is standing behind her, looking on. She has such a magic touch, the balls are beginning to float. On the wall behind Cassatt and Degas are several of their paintings. A shadowy version of Degas's silhouette of Cassatt from *At the Louvre* has left its image and has entered another Degas, *Dancers Practicing at the Barre*. Watching the billiard game is a cast of characters from various Cassatt paintings, chief among them the girl from her *Girl Arranging Her Hair* (1886). This canvas was painted by Cassatt as her response to Degas's observation to her one day that women should not express opinions about style because they had no idea what style was. Cassatt stormed to her studio and produced *Girl Arranging Her Hair* which, when it hung in the eighth and last Impressionist Exhibition, caused Degas to stop in his tracks and exclaim, "What style!" Then he acquired it.

The original taking-off point for *Mary's Turn* was a 1908 Gertrude Käsebier photograph of a billiard game. A figure of a woman is lining up a billiard shot, while the figure of a man, bathed in light, stands dreaming in a doorway. I was first attracted to the image by its mysterious light, but it was the drama of the purposeful woman and the pensive man that soon established the direction *Mary's Turn* was to take. It took me a long time to give an identity to the man in the doorway: first I thought I would turn him into Paul Durand-Ruel, who was both Degas's and Cassatt's dealer—but I could find no portrait of him. Finally a much more sig-

nificant and sadly appropriate figure suggested itself in the person of Ludovic Halévy, librettist to Offenbach and of Bizet's *Carmen*. He and his entire family were very close to Degas for most of his life. But the Halévys came from a Jewish background, and Degas's fanatic intolerance during the Dreyfus affair destroyed that relationship along with many others.

In an 1879 painting, Degas poses Halévy with an umbrella in a composition that directly prefigures *In the Louvre* (done later the same year). It seemed to me that Ludovic Halévy and Mary Cassatt could stand for the twin targets of Degas's two worst impulses: his lifelong misogyny and his curiously arbitrary eruptions of anti-Semitism. Both traits had an almost tragic effect on his later years, dividing him from the intellectual community of his world and isolating him almost as thoroughly as his encroaching blindness.

But, though these stresses of character—and particularly Degas's chauvinism—are central to *Mary's Turn*, they are only the framework on which to raise their antithesis: a celebration of the delights and surprises of art. I have hoped, I suppose, to suggest a world transfigured by the artist, in which accomplishment is everything: where the painted portrait rematerializes in the world of its painter, and in which a billiard game is coaxed into an exercise in levitation by the sure touch of Mary Cassatt.

I found *Mary's Turn* an exhilarating experience. I think it owes its fluency to *The Aspern Papers* and to the momentum the drawings for that portfolio initiated. *The Aspern Papers* was a kind of culmination for me. I worked at extracting as many highly developed images as I could from a consistent source and point of view, and rather than struggling with the impacted process that is my usual mode, I found that more images kept turning up in my mind, and that things came to a halt only when I hit the publisher's deadline.

As with the *Stolen Moments* series, I discovered that instead of poring over the intricacies of a single image for months, I could roam freely. For me, drawing has become the most immediate and direct translation of what I find in the depths and shoals of my preoccupations. My prints—which after all comprise the bulk of my work—involve a multiplicity of complex techniques that I trust give them their own validity and richness. These processes interest me because their very convolutedness works mysteriously and magically to bring me to their ultimate equilibrium. Still, there is no question that technique can keep one from immediacy, and prints are, by their nature, once removed from the artist's hand. In a sense, they derive their very strength from the surprises that lurk in complexity. But sometimes I sense a certain loss.

My favorite stage in making prints is when I am hunched over the plate and working directly into the metal. I get great satisfaction from the immediacy of engraving—a process very similar to drawing. In drawings I return to the primacy of touch.

Not infrequently I wish I were still a painter with a ten-foot canvas in front of me, and I sometimes regret that because I am primarily a printmaker I live necessarily outside the critically sanctioned center of the contemporary establishment. But this has proved in a great many ways to be a blessing; at least it has reinforced my move inward, which is, after all, not the worst place for an artist to be.

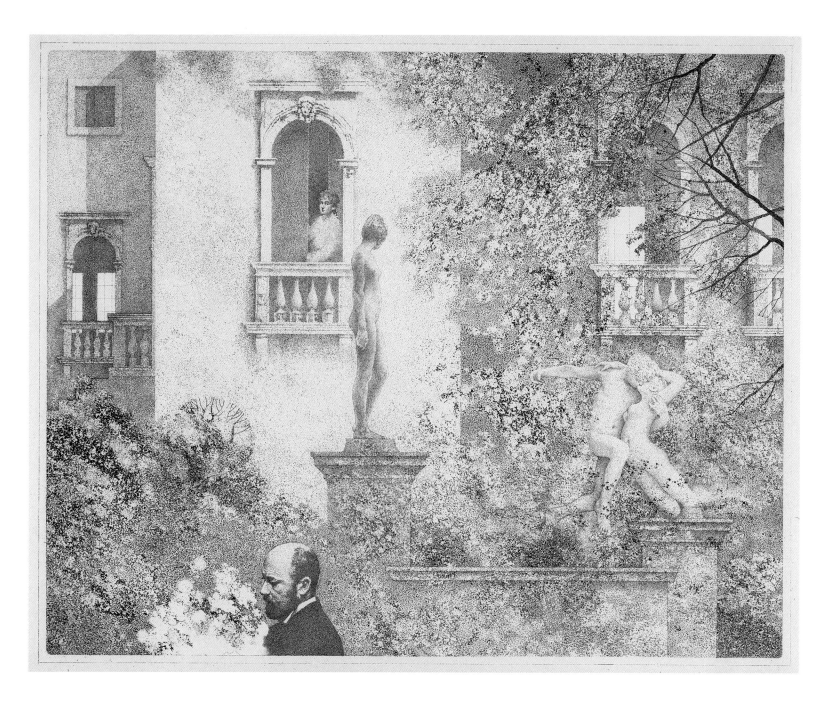

Garden with Henry, 1992, ink on Mylar,
9½ x 12 inches.

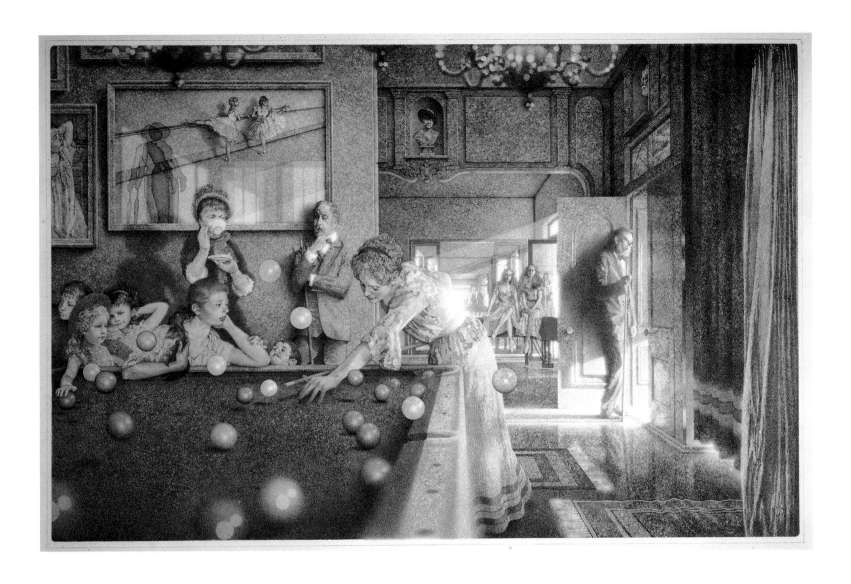

Mary's Turn, 1993, ink on Mylar, 18 x 28 inches.

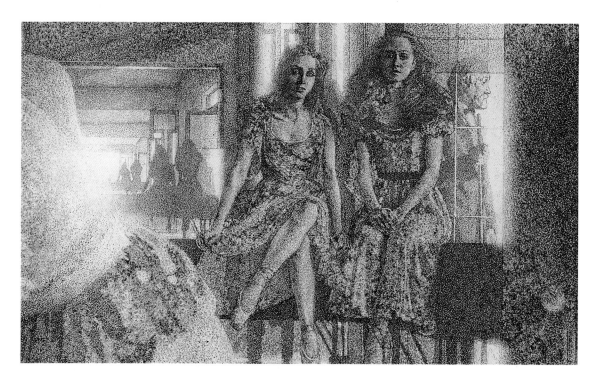

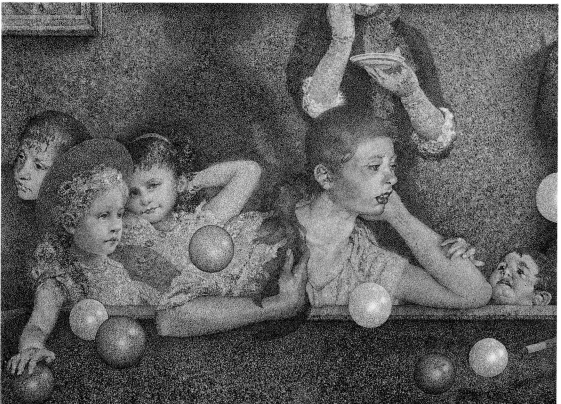

Mary's Turn, details.

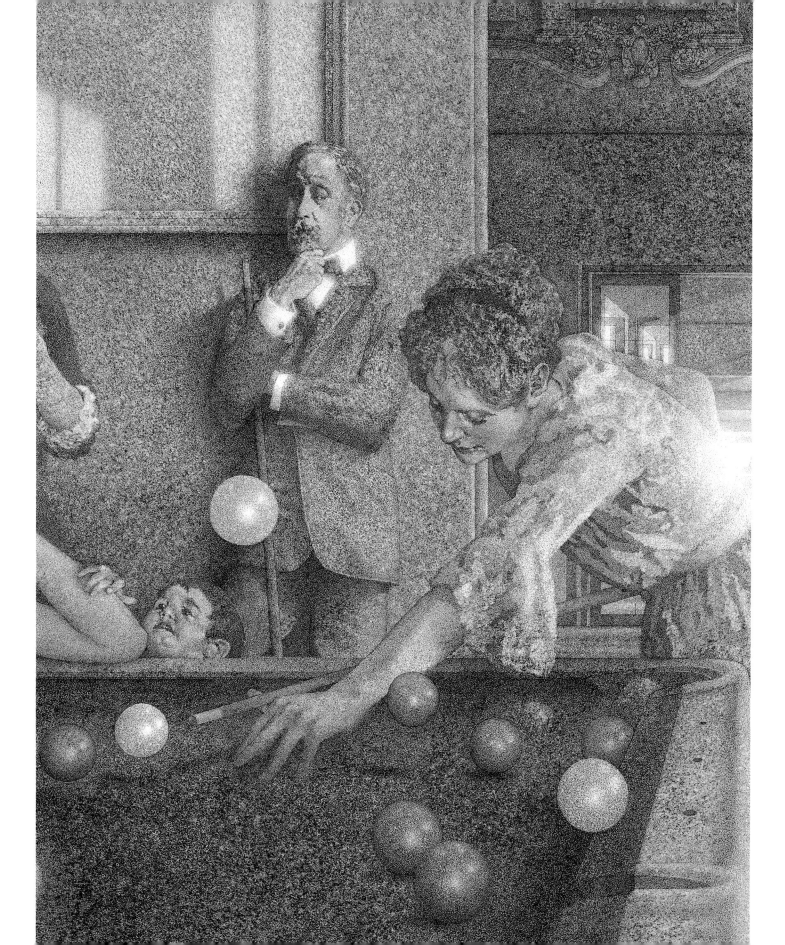

Chronology

1930
April 2: born Lower Merion, Pennsylvania.

1938
Family moves to Pittsfield, Massachusetts.

1944–48
Attend Darrow School, New Lebanon, New York.

1948–50
Attend Virginia Military Institute, Lexington, Virginia. First year: civil engineering; second year: humanities.

1950–54
Attend Yale University, School of Art and Architecture, New Haven, Connecticut; study under Josef Albers. Yale Summer School of Music and Art at Norfolk, Connecticut, 1953. B.F.A., 1954.

1954–55
Yale University Traveling Fellowship Grant. Year of informal travel in Europe, mainly Italy and France. Study music in Paris. Paint derivations of Cézanne.

1956–57
Residence in New Haven. Still painting derivations of Cézanne. Subsist by lettering store signs and selling Good Humor ice cream.

1958
Patience with deadbeat life and derived painting wanes. Become assistant registrar at Yale Art Gallery and shift to sculpture, now derivative of Henry Moore and Jacques Lipchitz.

1959
Apprentice as art teacher at Hamden Hall, Hamden, Connecticut, grades 2–7, and as art history lecturer at University of Bridgeport, Connecticut. Return to painting, now nonobjective, derivative of Stuart Davis.

1960
Return to Yale University. Teaching assistant in drawing. Painting now trying to be "action," muscular and generally macho. Prints begin to attract as the macho world of painting and the New York art scene frustrates and dismays me. Print world seems less contaminated. First lift-ground print is of a single tree.

1961
M.F.A., Yale University. June: marry Edith Cohn in New Haven.

1961–68
Instructor in basic design and drawing, Maryland Institute, Baltimore.

1962
Tested for colorblindness at Johns Hopkins University. Shocked at degree of deficiency. Black-and-white prints from now on!

1963
First solo show of graphics, Berkshire Museum, Pittsfield, Massachusetts. December: birth of son, Jeremy.

1964
Louis Comfort Tiffany Foundation Grant in Graphics. Enter first all-print exhibition, Boston Printmakers 16th Annual Exhibition, with *Panorama I.* December: birth of daughter, Naomi.

1964–69

Compulsively enter every graphics exhibition possible. Jeremy, Naomi, and Baltimore architectural motifs become main subjects.' Astonished to win sixteen awards in 1966 with *Street Scene* and *Garden*. Greed for prizes flourishes briefly, then begins to wane. Enthusiasm for exhibiting in general begins to fade.

1969

Move to rural Francestown, New Hampshire, having given up teaching for a year. With a barn hayloft converted for studio space, escape is complete. Begin *The Jolly Corner* suite and experimentation with light-sensitive techniques. First prize, IX Festival de Artes Gráficas, Cali, Colombia, and invited as juror to X Festival.

1970

Accept last formal teaching post, as instructor of graphics, Yale Summer School of Music and Art at Norfolk.

1971

Visiting artist, Dartmouth College, Hanover, New Hampshire. *The Jolly Corner* suite published.

1972

Grand Prize, 2nd International Biennial of Prints, Seoul, Korea. Solo exhibition, Corcoran Gallery of Art, Washington, D.C. Visiting artist, Yale University.

1973

Begin to find exhibiting as distracting as was teaching. Wonder if I am becoming a complete eccentric. The irony of non-exhibiting artist not entirely lost on me.

1975

First solo show in Europe, Galerie Georges Bernier, Paris.

1977

Peter Milton: Complete Etchings, 1960–1976 published by Impressions Workshop, Inc., Boston.

1979

Visiting artist, Yale University.

1980

After eighteen years of concentrated printmaking, decide to undertake discreet midlife crisis by leaving prints. Start two-year *Stolen Moments* graphite-on-drafting-film series. *The Jolly Corner* suite published in book form by Terra Nova Editions, London. Publication exhibition, Francis Kyle Gallery, London. Visiting artist, Columbia University, New York.

1981

Visiting artist, Middlebury College, Middlebury, Vermont.

1982

Under grant from Australian Council for the Arts, conduct printmaking workshop in Hobart, Tasmania. Lecture in Melbourne and Sydney.

1983

Drawing splurge has run its course. Discomfort with the idea of the specialized printmaker still gnaws. Concern about colorblindness thrown to the winds—start eight-foot canvas on *Les Belles et la Bête* theme. Artist-in-residence, Dartmouth College.

1984

Painting *The Rehearsal* has taken a year. Realization dawns that one painting a year doth not a prolific career make. Sail back to port and printmaking. *Interiors* series begins with *Family Reunion*.

1985

Visiting artist: University of Florida, Gainesville; State University of New York, Purchase; Rhode Island School of Design, Providence.

1988

Visiting artist, Yale University.

1989

Interiors series nearing end with six images completed. Begin to turn thoughts toward a new Henry James project, *The Aspern Papers*. After the measured pace of *Interiors*, I want to provoke myself into profusion of images and decide on drawings.

1990

Residence at Rockefeller Foundation Center, Bellagio, Italy. Drawings started in earnest. Lake Como the perfect place to set the mood for the Italian ambience of *The Aspern Papers*. Visit Venice and discover palazzo that is James's setting for the story. Medal of Honor, INTERPRINT '90, Lvov, Ukraine.

1991

The Aspern Papers interrupted to complete *Interiors* series with its seventh image, *The Train from Munich*. Award, Triennial of Graphic Arts, Cracow, Poland.

1992

The Aspern Papers completed. Original eight-to-twelve-image project is now nineteen images.

1993

Trade edition of *The Jolly Corner* published by David R. Godine, Boston. *The Aspern Papers* published by David R. Godine. Publication exhibition, Mary Ryan Gallery, New York.

Solo exhibitions

1963
Franz Bader Gallery, Washington, D.C.
Berkshire Museum, Pittsfield, Massachusetts
College of William and Mary, Williamsburg, Virginia
Twentieth Century Gallery, Williamsburg, Virginia

1965
Baltimore Museum of Art

1967
Franz Bader Gallery, Washington, D.C.
Print Club, Philadelphia

1969
Alpha Gallery, Boston
Troup Gallery, Dallas

1970
De Cordova Museum, Lincoln, Massachusetts
University of New Hampshire, Durham

1971
Alpha Gallery, Boston
Franz Bader Gallery, Washington, D.C.

Editions Limited Gallery, Indianapolis, Indiana
Lamont Gallery, Phillips Exeter Academy, Exeter, New Hampshire
Troup Gallery, Dallas

1972
Centro Colombo-Americano, Bogotá, Colombia
The Corcoran Gallery of Art, Washington, D.C.
Imprint, San Francisco
Museo de Arte Moderno "La Tertulia," Cali, Colombia
Richard Nash Gallery, Seattle
Optik Gallery, Amherst, Massachusetts
Print Club, Philadelphia
Talisman Prints, Laguna, California

1973
Cheney Cowles Memorial Museum, Spokane, Washington
Middlebury College, Middlebury, Vermont

1974
Kutztown State College, Kutztown, Pennsylvania

MacDowell Colony, Peterborough, New Hampshire
Schenectady Museum, Schenectady, New York
University of Nebraska, Lincoln
University of Oregon, Eugene

1975
Associated American Artists, New York
Galerie Georges Bernier, Paris
Biblioteca Luis-Angel Arango, Bogotá, Colombia

1976
Alpha Gallery, Boston

1977–81
International Exhibitions Foundation, Washington, D.C. (two concurrent traveling exhibitions to over forty American cities)

1979
Galerie Petites Formes, Osaka, Japan

1980
The Brooklyn Museum, New York
Francis Kyle Gallery, London

1981

Joint exhibition: Alpha Gallery, Boston (drawings), and Impressions Gallery, Boston (prints)

1982

Franz Bader Gallery, Washington, D.C.

Thorne-Sagendorph Art Gallery, Keene, New Hampshire

1983

Hood Museum of Art, Dartmouth College, Hanover, New Hampshire

Lamont Gallery, Phillips Exeter Academy, Exeter, New Hampshire

1984

Louis Newman, Beverly Hills, California

Jamie Szoke Gallery, New York

1985

Augen Gallery, Portland, Oregon

Graystone, San Francisco

1986

Franz Bader Gallery, Washington, D.C.

Hastings Gallery of Art, Hastings College of Law, San Francisco

1987

Allport Gallery, San Francisco

Franz Bader Gallery, Washington, D.C.

Freeport Art Museum, Freeport, Illinois

Louis Newman, Beverly Hills, California

John Szoke Gallery, New York

Van Straaten Gallery, Chicago

1988

Franz Bader Gallery, Washington, D.C.

Eastern Michigan University, Ypsilanti

Greenhut Galleries, Albany, New York

Francis Kyle Gallery, London

Print Club, Philadelphia

1989

Franz Bader Gallery, Washington, D.C.

1990

More Gallery, Philadelphia

1991

Franz Bader Gallery, Washington, D.C.

Davidson Galleries, Seattle

Francis Kyle Gallery, London

John Szoke Gallery, New York

1992

Edith Caldwell Gallery, San Francisco

Louis Newman, Beverly Hills, California

1993

Mary Ryan Gallery, New York

Selected public collections

Baltimore Museum of Art

Bibliothèque Nationale, Paris

British Museum, London

The Brooklyn Museum, New York

Carnegie Museum of Art, Pittsburgh, Pennsylvania

Cincinnati Art Museum, Cincinnati, Ohio

Cleveland Museum of Art, Cleveland, Ohio

The Corcoran Gallery of Art, Washington, D.C.

Currier Gallery of Art, Manchester, New Hampshire

The Detroit Institute of Arts

The Fine Arts Museums of San Francisco

Hirshhorn Museum and Sculpture Garden, Washington, D.C.

Hood Museum of Art, Dartmouth College, Hanover, New Hampshire

Library of Congress, Washington, D.C.

Los Angeles County Museum of Art

The Metropolitan Museum of Art, New York

The Minneapolis Institute of Arts, Minneapolis, Minnesota

Museo de Arte Moderno, Bogotá, Colombia

Museo de Arte Moderno, Cali, Colombia

Museum of Fine Arts, Boston

The Museum of Fine Arts, Houston

The Museum of Modern Art, New York

National Gallery of Art, Washington, D.C.

National Museum of American Art, Washington, D.C.

Philadelphia Museum of Art

The Phillips Collection, Washington, D.C.

Portland Museum of Art, Portland, Oregon

Seattle Art Museum

Yale University Art Gallery, New Haven, Connecticut

The Tate Gallery, London

Selected publications

Catalogue raisonné

McNulty, Kneeland, ed. *Peter Milton: Complete Etchings, 1960–1976.* Boston: Impressions Workshop, 1977.

Exhibition catalogues

Baro, Gene, ed. *Peter Milton: Drawing towards Etching.* New York: Brooklyn Museum, 1980.

Cochran, Malcolm, ed. *Peter Milton: Prints and Drawings.* Hanover, N.H.: Hood Museum of Art, Dartmouth College, 1982.

Lucie-Smith, Edward. *Peter Milton.* London: Francis Kyle Gallery, 1980.

McNulty, Kneeland, ed. *Peter Milton.* Washington, D.C.: International Exhibitions Foundation, 1977.

Peter Milton: Prints and Drawings. Introduction by Theodore F. G. Wolff. New York: John Szoke Graphics, 1984.

Articles

Baro, Gene. "Peter Milton." *Drawing: The International Review,* July 1980.

Case, W. D. "Books: The Jolly Corner." *Arts Magazine,* September 1972.

Craig, William, Jr. "A Pleasure of Illusions: The Art and Politics of Peter Milton." *Spectator,* February 1991.

Dinnage, Rosemary. "The Texture of Time and Space." *Times Literary Supplement* (London), February 8, 1980.

Ewins, Rod. "Workshop with Peter Milton." *Imprint* (Print Council of Australia), June 1982.

Finkelstein, Irving L. "Julia Passing: The World of Peter Milton." In *Artists Proof: Annual of Prints and Printmaking.* New York: New York Graphic Society, 1971.

Frankenstein, Alfred. "A Remarkable Series of Milton Prints." *San Francisco Chronicle,* May 20, 1978.

Goldman, Judith. "Exploring the Possibilities of the Print Medium." *Artnews,* September 1973.

Halasz, Piri. "The Metaphysical Games of Peter Milton." *Artnews,* December 1974.

Hays, Kim. "Etched in Memory." *Boston Phoenix,* January 20, 1981.

Kessler, Pamela. "Peter Milton's 'Paradise' Engraved." *Washington Post,* October 9, 1987.

Linnane, Fergus. "Train Keeps a Date with Destiny." *European Elan,* November 1–3, 1991.

Louch, Roberta. "Peter Milton ... In Conversation." *Visual Dialogue,* Summer 1979.

Melville, Robert. "Gallery: The Feeling of Actuality." *Architectural Review* (Westminster, England), August 1971.

Parrill, William. "Peter Milton, Henry James and 'The Jolly Corner.'" *Innisfree* (Southeastern Louisiana University), 1977. Reprinted in *New Boston Review,* Fall 1977, and as foreword to *The Jolly Corner* (Boston: David R. Godine, 1993).

Pepich, Bruce W. "Peter Milton." *Art Gallery International,* May/June 1989.

Richard, Paul. "Milton, the Magician: The Triumph of Beautiful Drawing." *Washington Post,* April 3, 1982.

Ross, John, and Clare Romano. "Peter Milton's Procedure." In John Ross and Clare Romano, *The Complete Printmaker,* 97–99, 225. New York: Free Press, 1972.

Shapiro, Harriet. "All Realism Is Visionary: A Reach into the Ambiguous Realm of Peter Milton." *Intellectual Digest,* November 1972.

Simmons, Rosemary. "Graphics: Peter Milton." *Arts Review* (London), February 15, 1980.

Tarshis, Jerome. "The Dynamics of Recollection." *Christian Science Monitor,* January 15, 1979.

Wolff, Theodore. "Milton's Mysterious World of Etching." *Christian Science Monitor,* March 31, 1980.

———. "The Many Masks of Modern Art: What Links Dürer and Milton.""*Christian Science Monitor,* March 2, 1982.

———. "What Links Dürer and Milton." In Theodore Wolff, *The Many Masks of Modern Art.* Boston: Christian Science Publishing Society, 1989.